Dear Kelican,
This book has
a nice good ? fly leaf.
I hope we have a nice, loving
time.
Bill

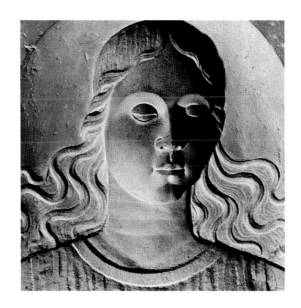

VENICE
City of Haunting Dreams

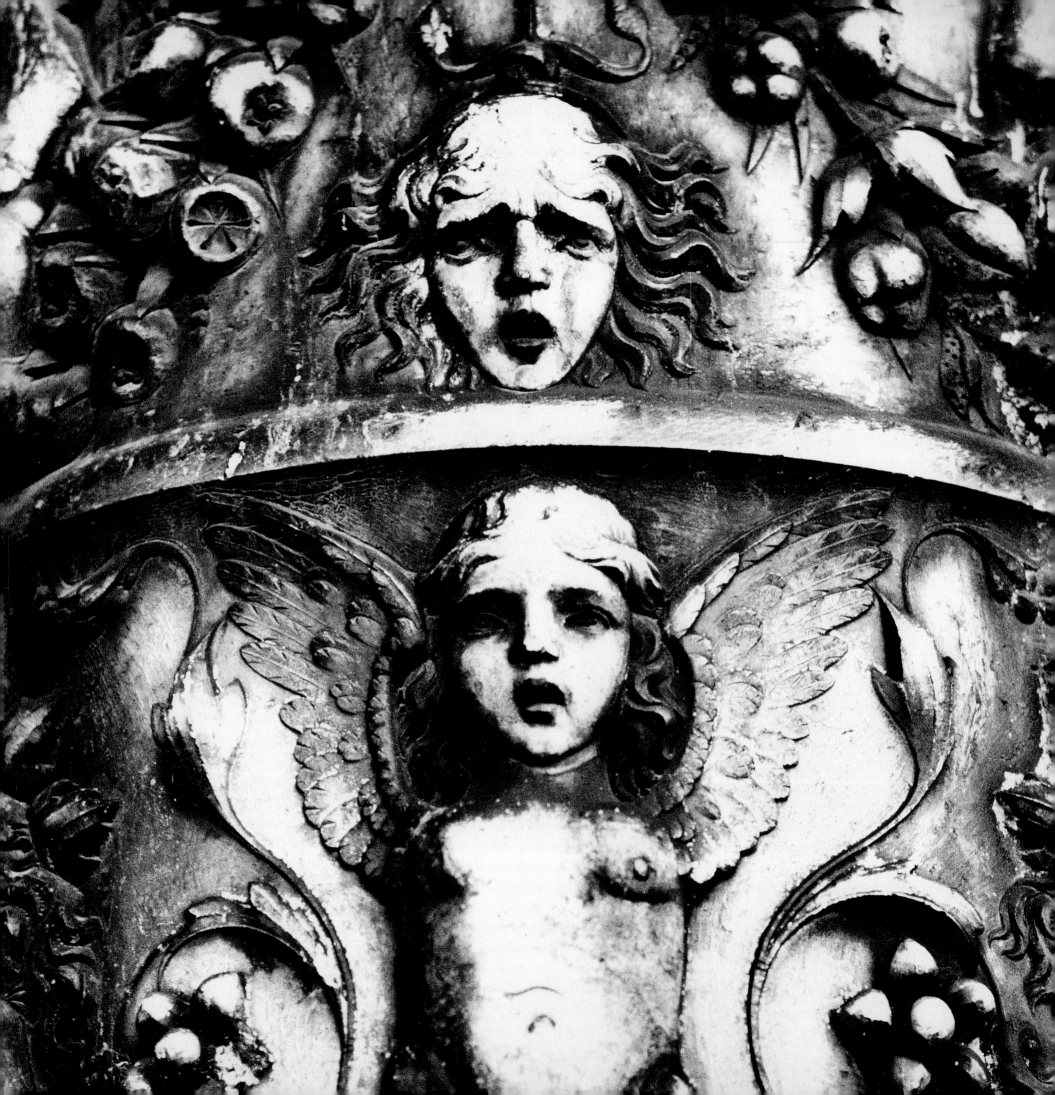

VENICE
City of Haunting Dreams

SIMON MARSDEN

Little, Brown and Company

BOSTON · NEW YORK · LONDON

For my mother,
a calm spirit in an uncertain world

———————————————

A LITTLE, BROWN BOOK

FIRST PUBLISHED IN 2001
BY LITTLE, BROWN AND COMPANY (UK)

TEXT AND PHOTOGRAPHS COPYRIGHT © 2001
BY SIMON MARSDEN

A CIP CATALOGUE RECORD FOR THIS BOOK
IS AVAILABLE FROM THE BRITISH LIBRARY

ISBN 0-316-64536-2

DESIGNED BY ANDREW BARRON
& COLLIS CLEMENTS ASSOCIATES
PRINTED AND BOUND IN ITALY

LITTLE, BROWN AND COMPANY (UK)
BRETTENHAM HOUSE, LANCASTER PLACE
LONDON WC2E 7EN

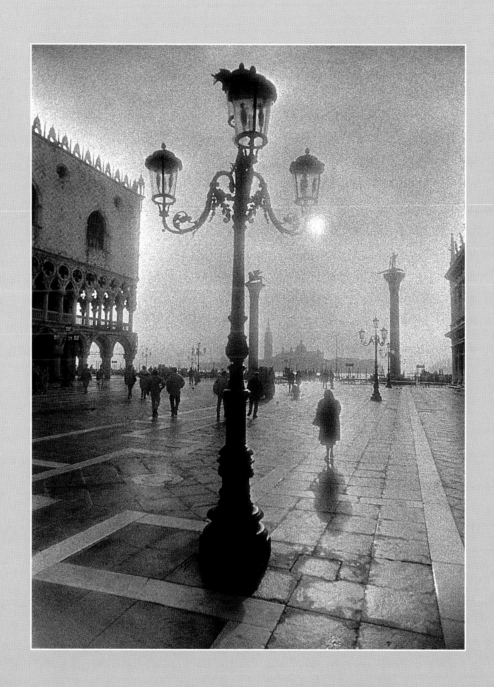

*W*hen I went to Venice, I discovered that my dream had become – incredibly, but quite simply – my address.

MARCEL PROUST
Remembrance of Things Past, 1925

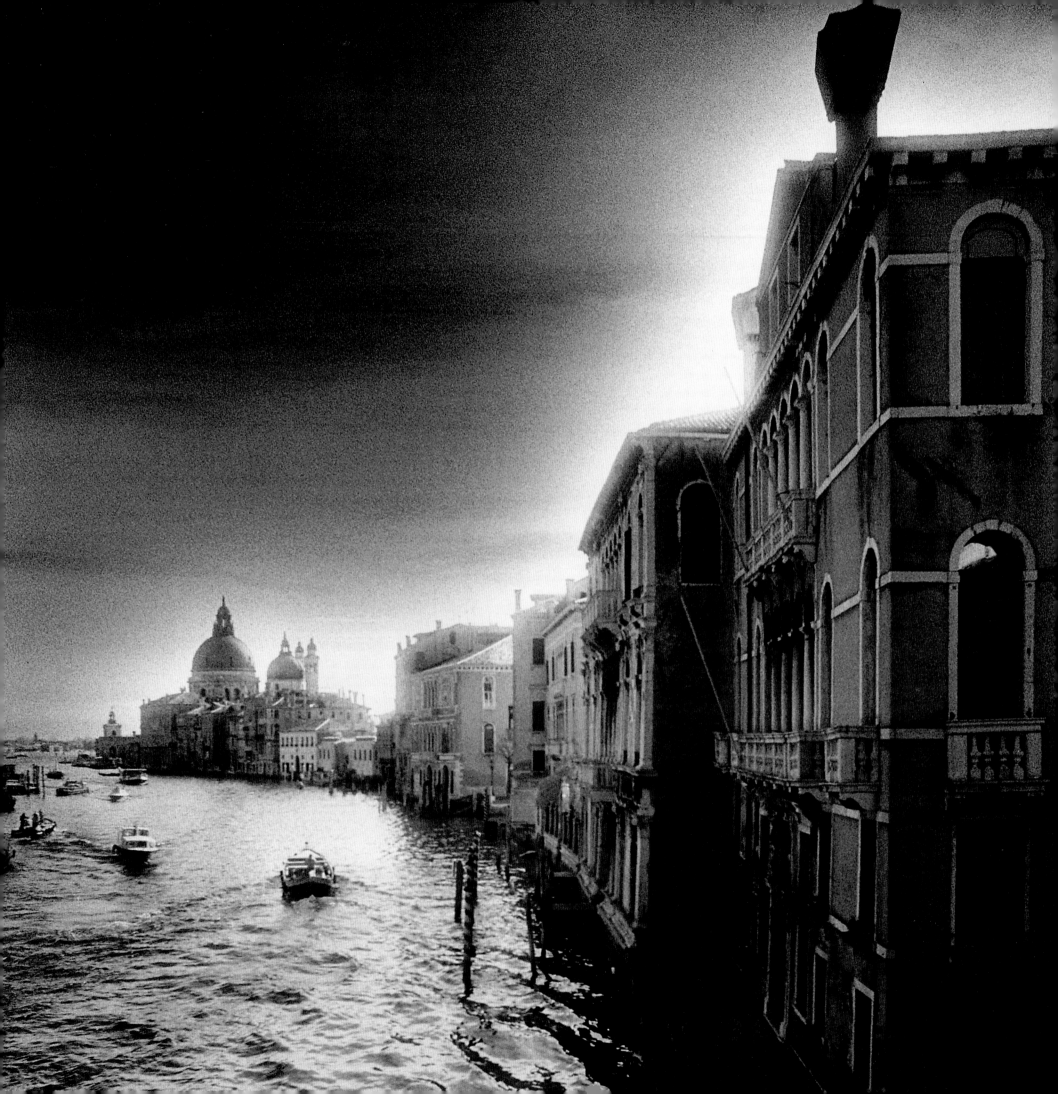

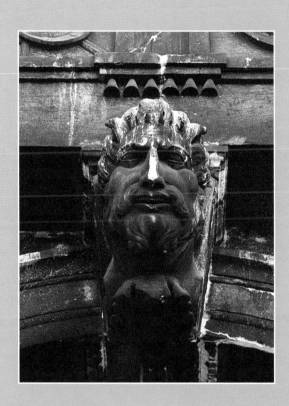

INTRODUCTION

Venice appears to us as if in a dream, its breathtaking architecture and overwhelming weight of history challenging the soulless uniformity of our modern-day world. This unique city of so many contradictions, of shifting light and dark shadows, subtle movement and fleeting glances, quickly seduces us with its timeless beauty. It is only later that we become aware of its other, more sinister side.

Walk away from St Mark's Square, and disappear into the maze of narrow streets and canals, crossed by ancient bridges. Here you find yourself in another world where time has stood still, preserved like the cadavers of the saints that lie in the many dark, melancholy churches.

Before long you are standing in a moss-grown courtyard – how you got there you don't know. In front of you is a rotting wooden door that appears to hide a terrible secret. Out of the corner of your eye you see a lizard dart between the crumbling brickwork. You begin to feel lost and alone, as if you are at the entrance to another world. As you retrace your steps over a bridge, a rat swims across the canal to disappear beneath the massive iron gates at the water entrance of a ruined palazzo. As the mist begins to roll in from the lagoon, you stare at the grotesque stone head that surmounts these gates. The smell of stagnant water is overpowering and the only sound is the haunting cry of a gondolier. There is the pervasive sense that a second spectral city

exists beneath the façade of everything you see; a timeless realm that we visit in our dreams.

'Deep into the darkness peering, long I stood there, wondering, fearing, doubting, dreaming dreams no mortals ever dared to dream before.'
(Edgar Allan Poe, 'The Raven', 1845)

Ancient chronicles tell us that the origins of the Venetian Empire rose from within the mists of its lonely lagoon as early as the fifth century AD, when migrants from the surrounding cities of the Veneto took refuge on its many small islands, fleeing from the invading armies of Goths and Huns. Many of these islands now lie deserted, their broken walls and wind-blasted trees the refuge of wildlife. Others have disappeared below the murky waters, their inhabitants falling victim to poverty and the plague.

Between the Lido and Venice lies the infamous Canale Orfano, the scene of judicial drownings in the Middle Ages. Here, in the dead of night, condemned prisoners from the dark cells below the Ducale Palace were put in a sack, their hands bound and their bodies weighted, to be thrown overboard to their watery graves. The channel is said to be haunted by their cries, an area where no fisherman will cast his net.

The Venetian State retained its power and supremacy up until the end of the eighteenth century through tyranny and fear. Power lay in the hands of a few patrician families from whom the ruling Doge and the secretive Council of Ten were chosen, sitting in judgement of anyone who was thought to be an enemy of the State. Horrific tortures were carried out in the dungeons below the Palace, many of the victims falsely betrayed by their fellow citizens, their mutilated bodies left to hang in public places as a warning to the populace.

The imprint of the past can be seen everywhere in the city, and suggestions of the supernatural abound. The eerie faces of time-worn statues stare down from every building, some human, others portraying weird and wonderful beasts. Strange birds and reptiles entwined with skeletal motifs adorn the ancient coats-of-arms of the noble Venetian families, and the spirits of the night haunt their decaying palazzos. On the Grand Canal the Ca' Mocenigo Vecchia once belonged to the powerful Mocenigo dynasty who produced no less than seven Doges. Giovanni Mocenigo entertained the sixteenth-century alchemist Giordano Bruno here in a vain attempt to discover his occult secrets, but later denounced him to the Vatican. The alchemist was burned to death in Rome, but his ghost is still said to return to the mansion.

The Palazzo Dario is said to be cursed, and brings misfortune to anyone who resides there. The Renaissance palace is encrusted with medallions of coloured marble, a strange and alluring building that appears to be about to disintegrate and collapse into the Canal. In the eighteenth century it was home to the historian Rawdon Brown, who committed suicide. An important art collector was later murdered there and, more recently, Kit Lambert, the manager of the English rock group the Who, died in suspicious circumstances in the building. The last owner, Raul Gardini, an Italian businessman, shot himself.

The Casino degli Spiriti stands alone at the end of a promontory facing the island cemetery of San Michele. The house had a reputation as the scene of love trysts and debauchery over the centuries, and legend claims that the influential Venetian painter Giorgione died there in an orgy in 1510. Until recently an almost daily procession of gilded funeral gondolas would pass it by on their way to the burial ground. Tradition tells of a Venetian gentleman who once owned it, whose wife was having an affair with his best friend. When her lover

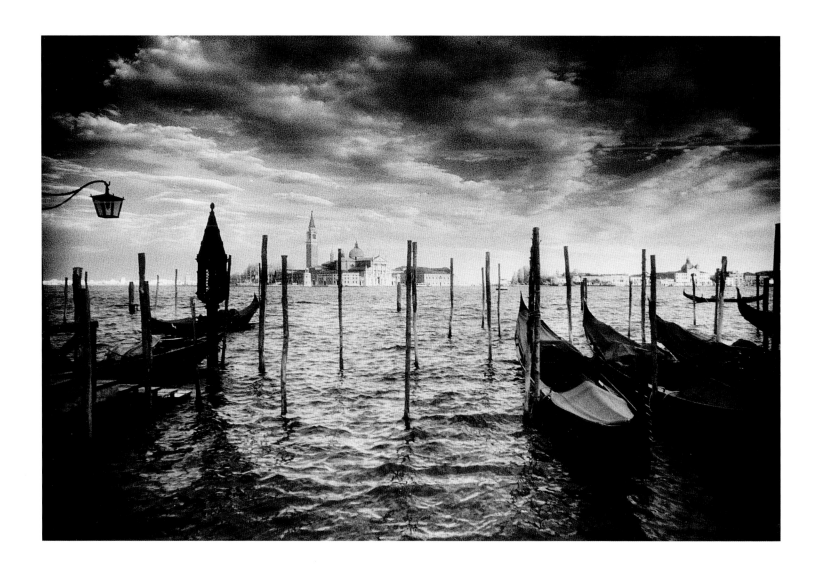

died she pined away and quickly followed him to the grave. At her wake her maid sat watching her body in the old house as midnight approached, when suddenly the ghost of her lover appeared. Picking up her corpse he ordered the servant to lead them downstairs with her lantern, but the terrified girl fell into a swoon and never recovered her sanity.

By the beginning of the nineteenth century the independence of the Venetian Empire, that had endured for over a thousand years, lay in ruins. The greatest sea power of her day had been conquered by a French army led by Napoleon Bonaparte, and in January 1806 the Venetians awaited the arrival of the Emperor in trepidation. His entry to the city was accompanied by a show of magnificent pageantry, and it is said that over four thousand torches illuminated St Mark's Square – Napoleon later described this architectural wonder as 'the finest drawing-room in Europe'. But his almost insane dislike of the Republic and all that it stood for drove him to desecrate and humiliate the city. All statues and emblems of the evangelical lion of St Mark, the symbol of Venice, were sought out and destroyed, and the city, whose beauty had earned it the title 'La Serenissima', saw its hoard of Byzantine treasures and resplendent paintings and sculptures pillaged by the invading force. Even the Doge's regal state barge, the 'bucintoro', was towed in front of St George's Island where it was set on fire and is said to have burned for over a week before its many ornate gold carvings succumbed to the flames.

But in truth Venice's decline had begun as early as 1423, on the death of the Doge Tomaso Mocenigo, when on the accession of his successor, Francesco Foscari, the city kept festival for a whole year, and in the words of John Ruskin, 'she now sowed in laughter the seeds of death'. By the eighteenth century she wore the mask of perpetual revelry and her hedonistic decadence had become a Mecca for the degenerate youth of Europe, who abandoned themselves to a lifestyle of uninhibited excess through gambling, drink and the sins of the flesh. At the dawn of the sixteenth century there were over ten thousand registered prostitutes in Venice, who would stand stripped to the waist in the doorways of the brothels, the higher class courtesans plying their trade in more palatial surroundings.

The Benedictine monastery on the island of San Servolo became an asylum for aristocrats, and was immortalised by Shelley in his evocative poem *Julian and Maddalo* as a 'windowless, deformed and dreary pile', where 'through the black bars in the tempestuous air, I saw like weeds on a wrecked palace growing, long tangled locks flung wildly forth, and flowing'. The less fortunate lunatics were left to roam the streets of the city. Shelley's heroic companion, the great English romantic Lord Byron, arrived in Venice in 1816 and proceeded to indulge his fantasies at will. He stayed in the Palazzo Mocenigo on the Grand Canal with fourteen servants, a dog, a monkey, a fox, a wolf and a never-ending succession of lovers. 'Everything about Venice', wrote the poet, 'is like a dream'.

In no other city in the world can one feel so reckless surrounded by such beauty. It is a magical place, a sublime monument to human art, where anything seems possible – a sensual feeling that one can live out one's fantasies as one pleases. All our conceptions of life are questioned until we begin to wonder where reality lies. The faces of the ancient statues start to uncannily resemble the masked revellers of the carnival as they glide between the faded palazzos like phantoms from another age.

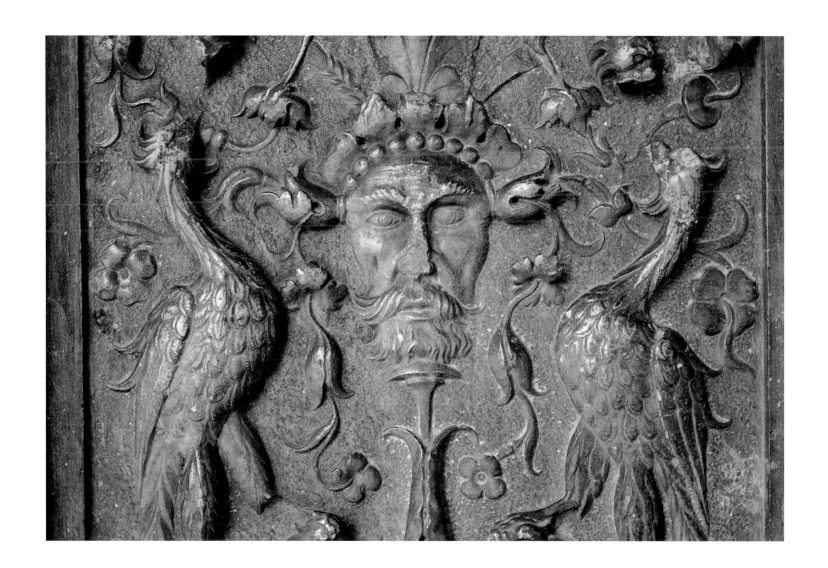

Today we are told that the past no longer bears any relevance to the present or future, therefore dismissing the myriad souls who have lived before us and the culture they created. If we are to believe science, we have no soul, but the evidence is here, in Venice, in the beauty of the architecture, the peace and serenity of the churches, and the magic of the art and music. Here one can regain some spiritual belief and humility away from an increasingly ugly world that is being nurtured on a philosophy of mindless self-gratification, where we are not at peace with ourselves or nature, but deluded by the arrogance of our own self-importance.

'I never before saw the thing that I should be afraid to describe, but to tell what Venice is, I feel to be an impossibility'. (Charles Dickens, Extract from a letter to his friend John Forster, dated 12 November 1844)

Because of the unique geographical situation and the singular history of their city, Venetians often feel themselves apart from the rest of mainstream life, and with this sense of isolation there comes a certain sadness that surrounds all things that are remote from reality. Creative people are also 'outsiders', often working alone with only their imagination as a friend, but in Venice they find a communal conversation with fantasy. The world's greatest artists, composers, writers and philosophers have always been drawn to this, the most romantic of cities, in their search for a higher form of consciousness, but the sum total of Venice is far greater than mere mortals can portray. Everything built, painted, imagined was to a higher order. The Renaissance painter Andrea Mantegna's last work, 'San Sebastiano', can be found in Ca' d'Oro. It was discovered in his studio after his death, and at the foot of the picture is this inscription:
Nil Nisi Divinum Stabile Est, Caetera Fumus
Nothing But God Endures, The Rest Is Smoke.

The enigma of Venice that these artists have attempted to evoke over the centuries is far more mysterious than our conscious minds can conceive. Jung believed that below the personal unconscious of the individual there lies the far greater 'collective unconscious' of our race, perhaps of all living creatures. It is the search for this hidden knowledge or glimpse of the infinite that the city inspires.

'It is a fact that almost everyone interesting, appealing, melancholy, memorable, odd, seems at one time or another, after many days and much life, to have gravitated to Venice by a happy instinct, settling in it and treating it, cherishing it, as a sort of repository of consolations; all of which today, for the conscious mind, is mixed with its air and constitutes its unwritten history. The deposed, the defeated, the disenchanted, the wounded, or even only the bored, have seemed to find there something that no other place could give.' (Henry James, *Italian Hours*, 1909)

At night the city is at its most intangible, and late one summer's evening I took a boat ride alone down the Grand Canal, where the dark waters mirrored the loneliness of the night sky. Mist hung like a veil over the moonlit palazzos and there was a silence more powerful and lasting than man. As my boat re-entered the lagoon, I tried to hold back my tears, reflecting on what might have been, for all that life had promised but could never deliver, glimpses of my childhood's forgotten dreams.

Simon Marsden

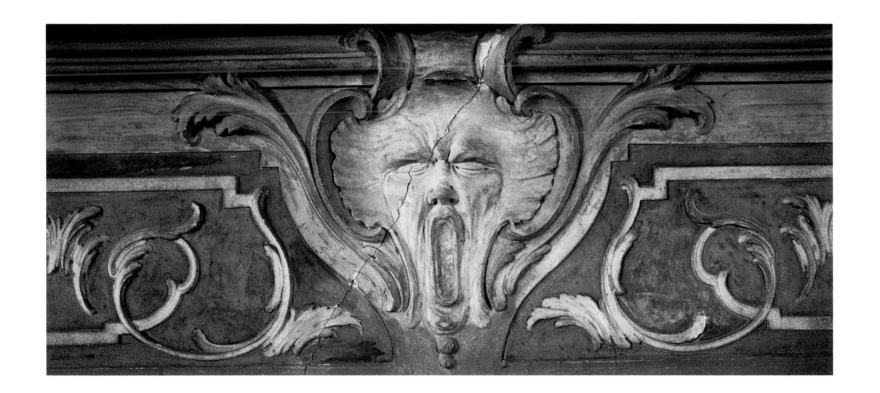

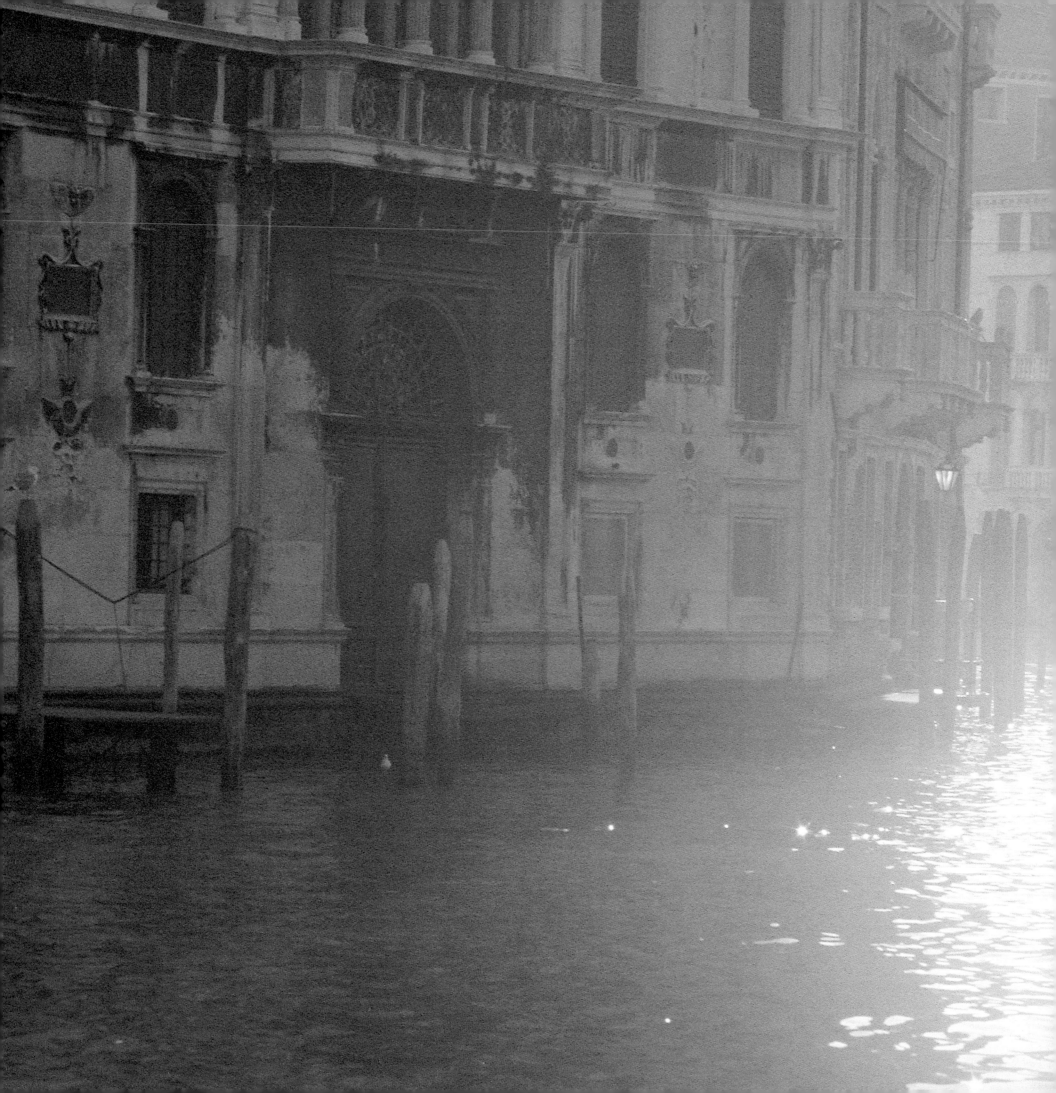

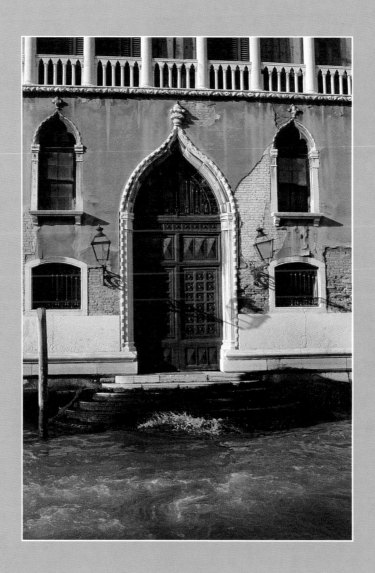

*H*ow strange, yet how beautiful was the first view of Venice! It seemed in the distance like a floating city, its domes, spires, cupolas, and towers, glittering in the sunbeams, and looked so glorious, that I could have fancied it one of those optical illusions presented by a mirage. As we entered the Grand Canal, the reality of the scene became impressed on my mind, and the grandeur of the houses, with the rich and solid architectural decorations lavished on them, formed so striking and melancholy a contrast to the ruin into which they are fast falling, that the scene awakened feelings of deep sadness in my breast. The palaces looked as if the touch of some envious wizard had caused them to decay, long ere Time the destroyer would have scathed them; and this premature ruin has in it something much more mournful than that gradually effected by the lapse of years . . .

MARGUERITE, COUNTESS OF BLESSINGTON
The Idler in Italy, 1840

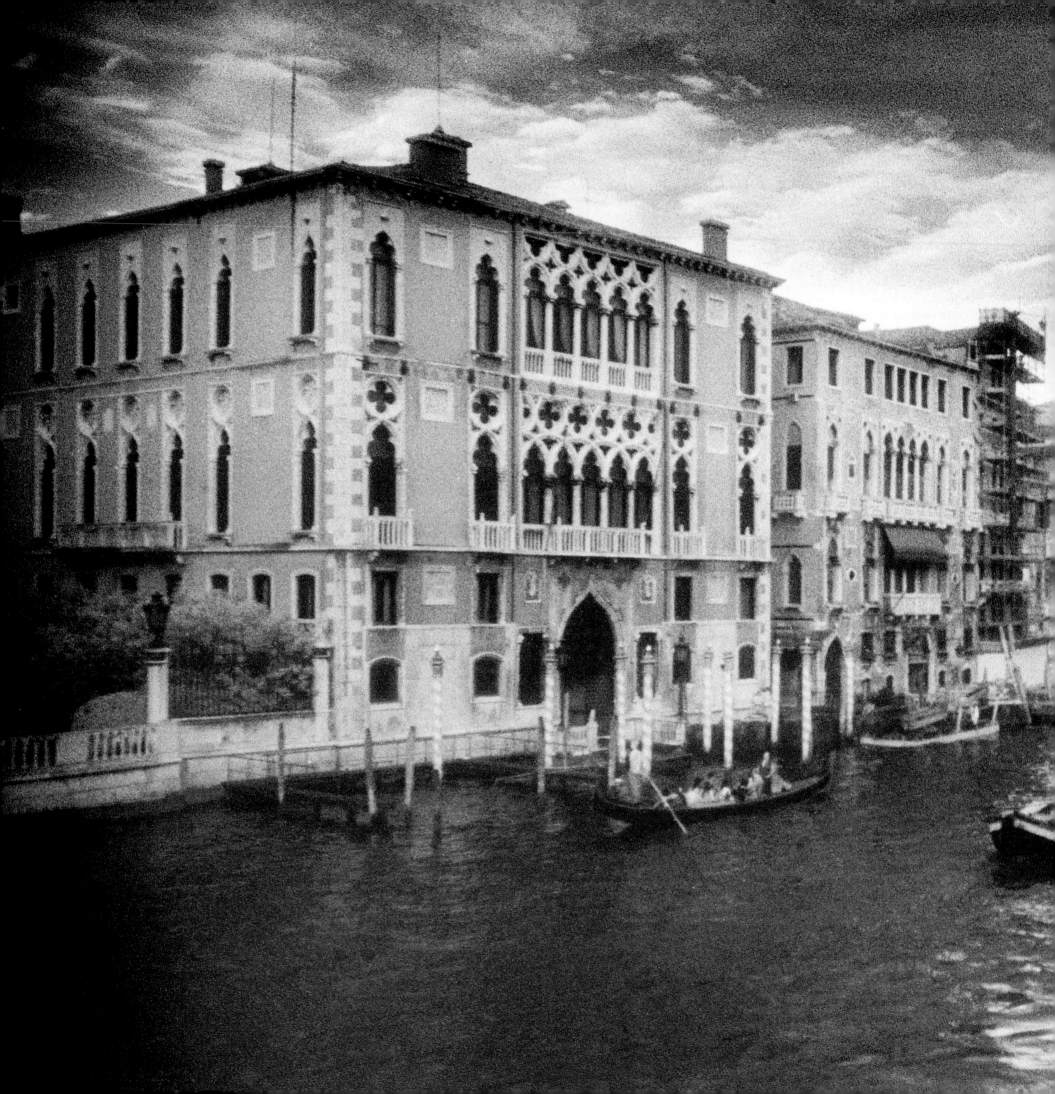

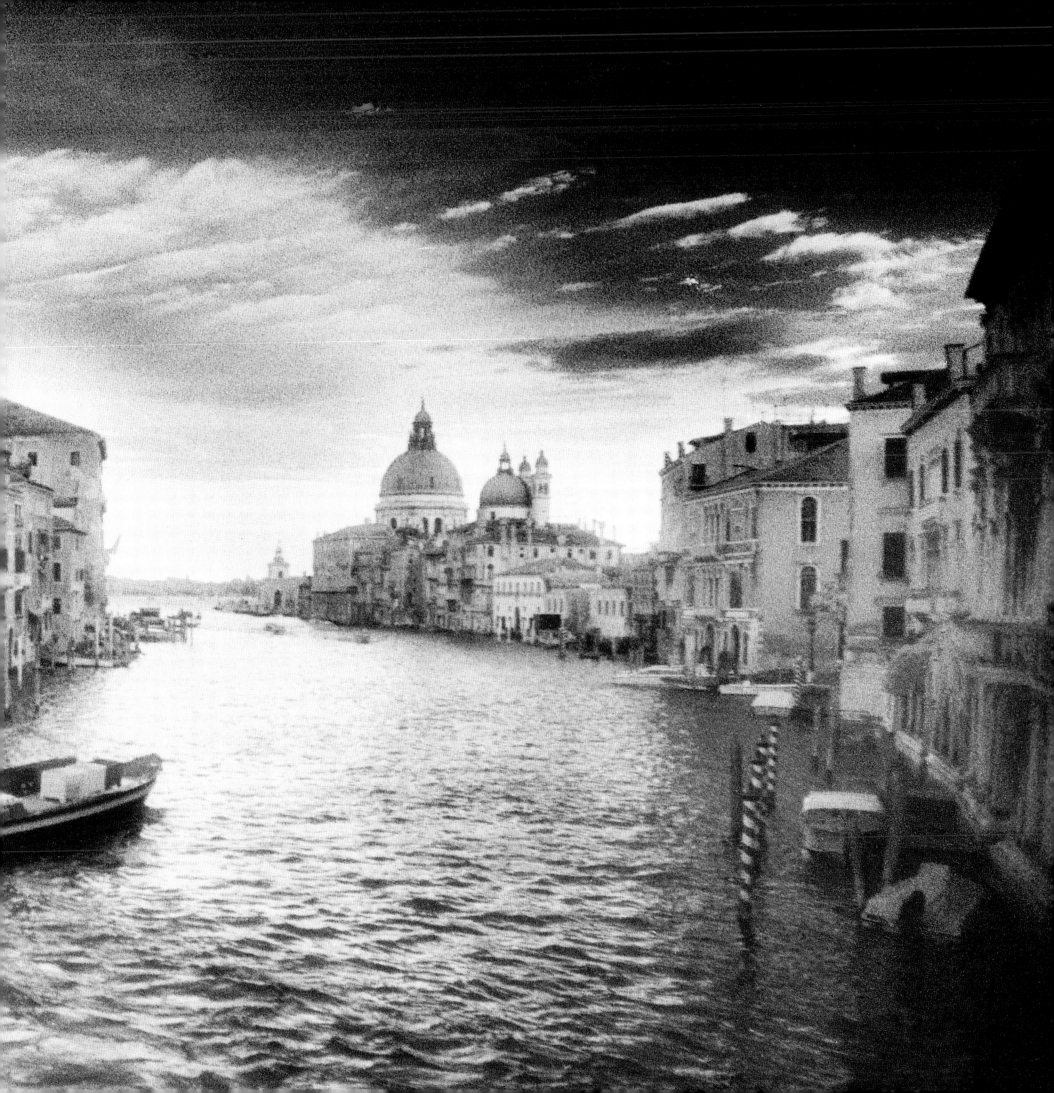

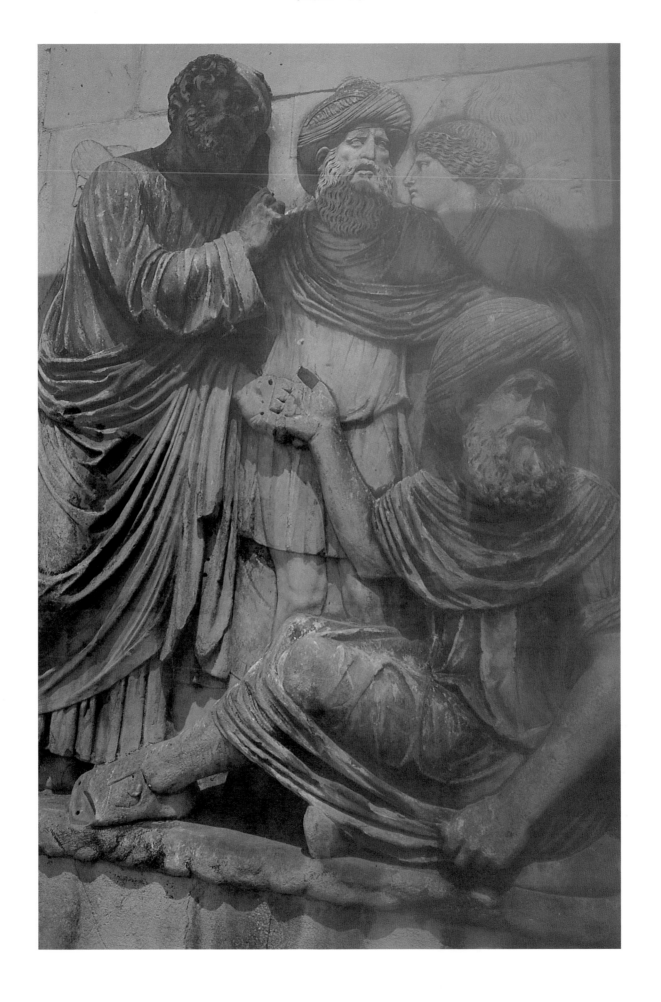

Venice! – the sea that flows thro' thy fair streets
Should surely be a weeping sea of tears,
Mourning thy funeral Beauty's faded years,
And all that sadly there the grieved eye meets!
My Heart, thy charms full sorrowfully greets,
Too sad thy splendour to my Soul appears! –
And yet thy melancholy more endears –

More wins to thee! – whose tale loud fame repeats!
Where are thy monarch-nobles of the old days?
Where thy Sea-Caesars? – Doges of proud name! –
Where thy vast victories, past all count or praise?
Played for between Oblivion pale and Fame!
In thee a Queen-like Phantom meets our gaze;
Thine is the Ruin! – be all Earth's – the Shame!

LADY EMMELINE STUART-WORTLEY
'On Venice', from *Sonnets*, 1839

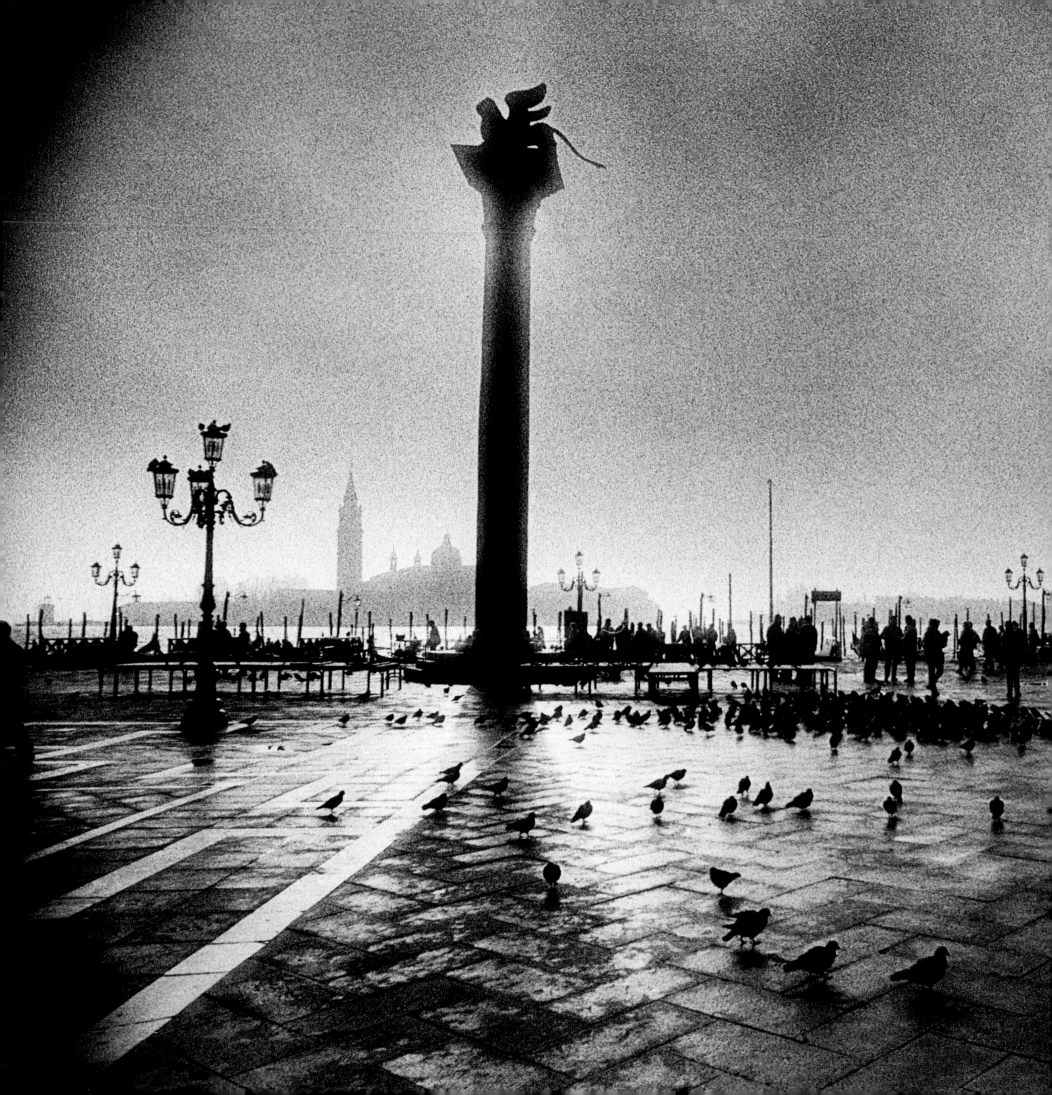

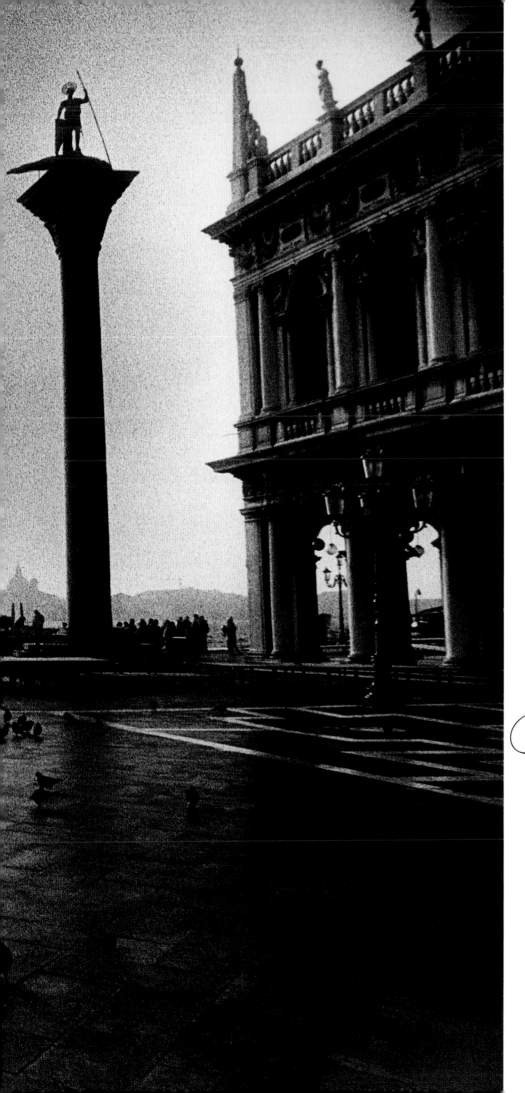

My dear fellow, nothing in the world that ever you have heard of Venice, is equal to the magnificent and stupendous reality. The wildest visions of the Arabian Nights are nothing to the piazza of Saint Mark, and the impression of the inside of the church. The gorgeous and wonderful reality of Venice is beyond the fancy of the wildest dreamer. Opium couldn't build such a place, and enchantment couldn't shadow it forth in a vision. All that I have heard of it, read of it in truth or fiction, fancied of it, is left thousands of miles behind. You know that I am liable to disappointment in such things from over-expectation, but Venice is above, beyond, out of all reach coming near, the imagination of man . . .

CHARLES DICKENS

Extract from a letter to his friend John Forster, dated 12 November 1844

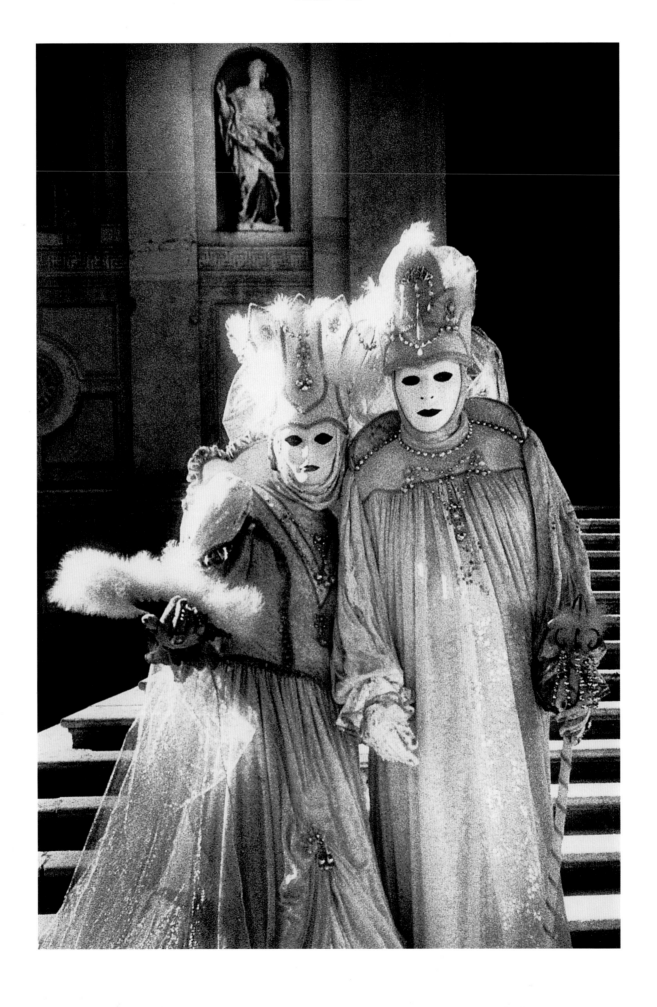

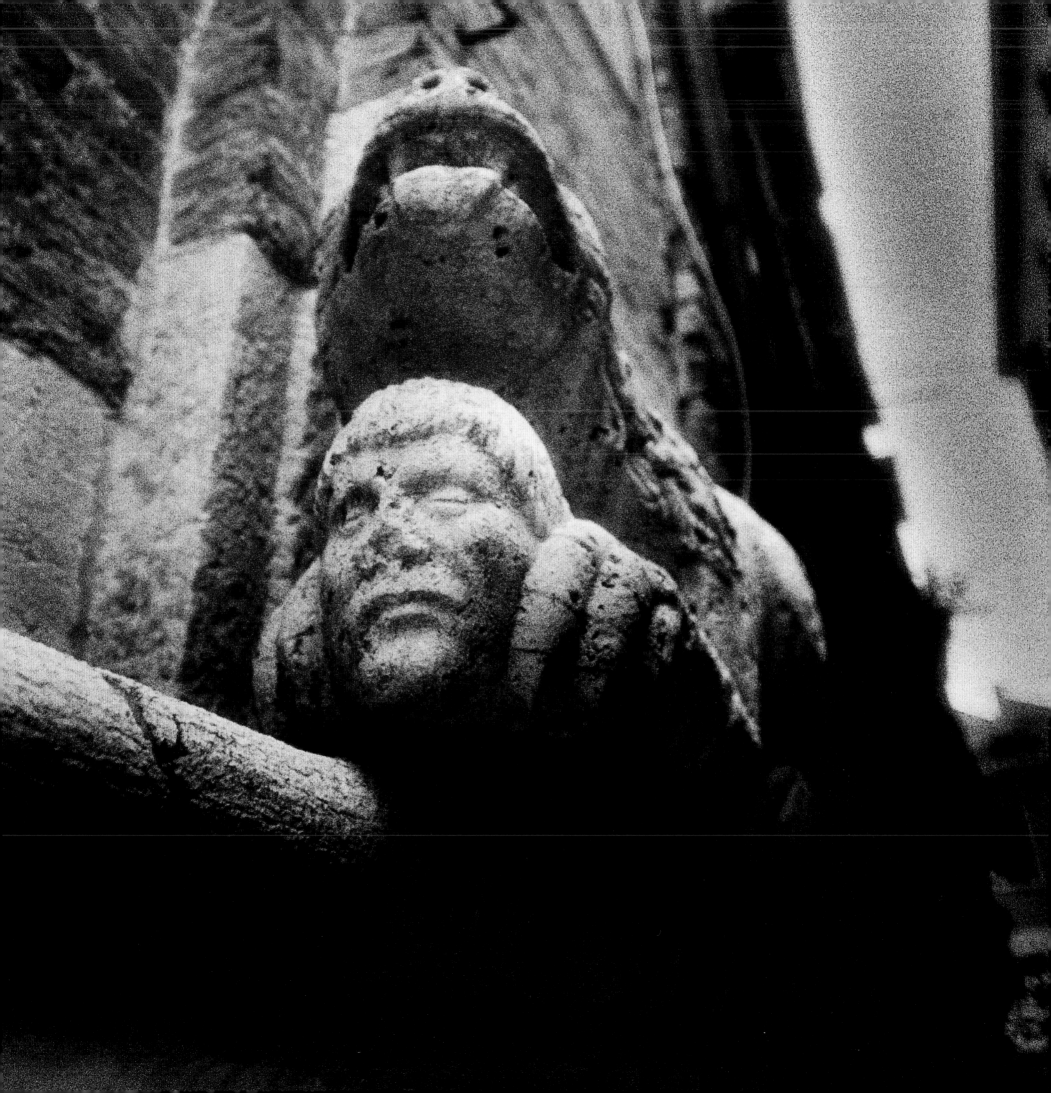

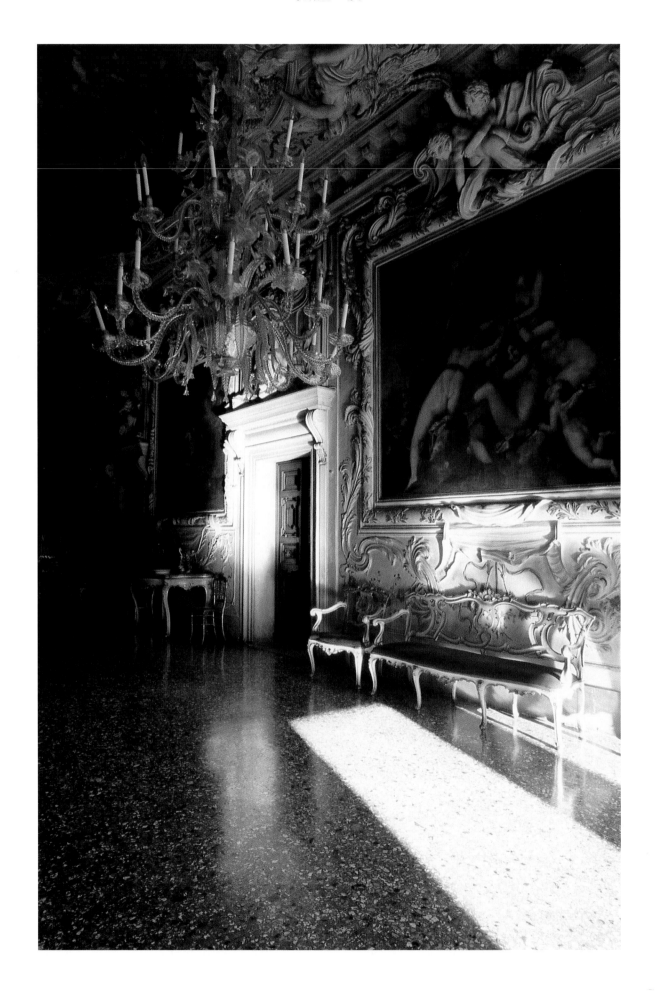

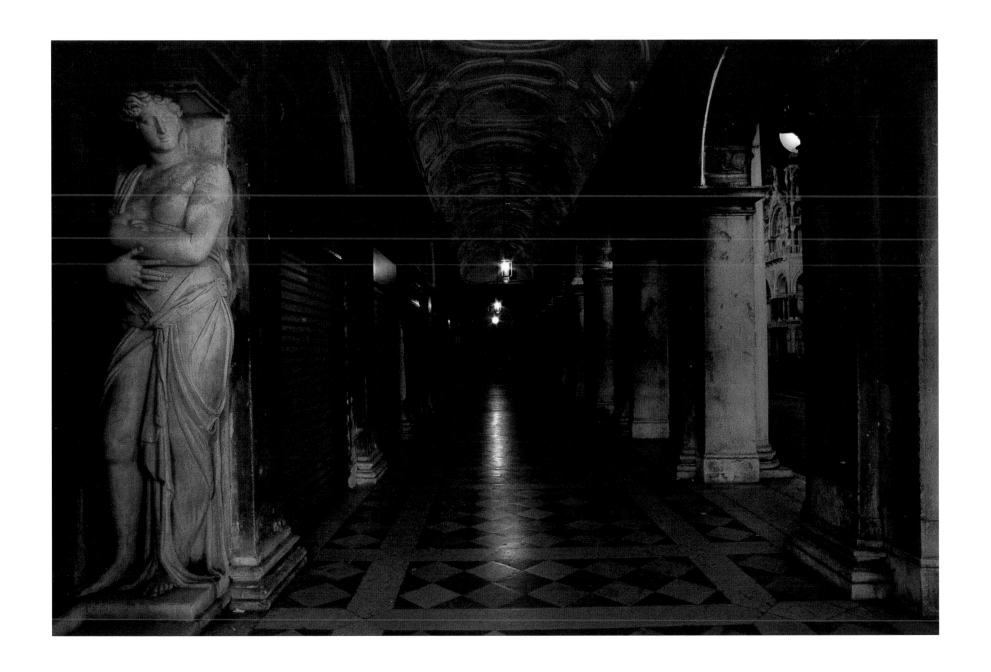

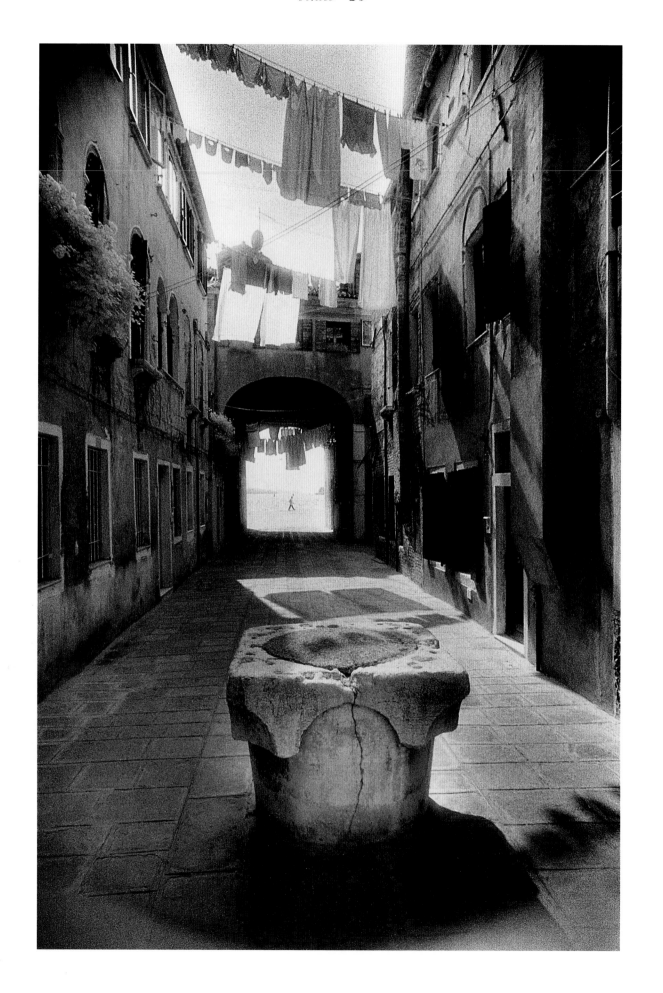

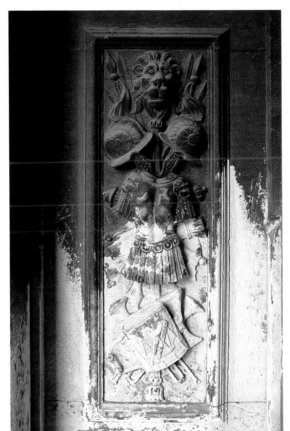

After dinner, I went out by myself, into the heart of the enchanted city where I found myself wandering in strange regions like a character in the Arabian Nights. It was very seldom that I did not, in the course of my wanderings, hit upon some strange and spacious piazza of which no guidebook, no tourist had ever told me.

I had plunged into a network of little alleys, *calli* dissecting in all directions by their ramifications the quarter of Venice isolated between a canal and the lagoon, as if it had crystallized along these innumerable, slender, capillary lines. All of a sudden, at the end of one of those little streets, it seemed as though a bubble had occurred in the crystallized matter. A vast and splendid *campo* of which I could certainly never, in this network of little streets, have guessed the importance, or even found room for it, spread out before me flanked with charming palaces silvery in the moonlight. It was one of those architectural wholes towards which, in any other town, the streets converge, lead you and point the way. Here it seemed to be deliberately concealed in a labyrinth of alleys, like those palaces in oriental tales in which mysterious agents convey by night a person who, taken home again before daybreak, can never again find his way back to the magic dwelling which he ends by supposing that he visited only in a dream.

On the following day I set out in quest of my beautiful nocturnal piazza, I followed *calli* which were exactly like one another and refused to give me any information, except such as would lead me farther astray. Sometimes a vague landmark which I seemed to recognize led me to suppose that I was about to see appear, in its seclusion, solitude and silence, the beautiful exiled piazza. At that moment, some evil genie which had assumed the form of a fresh *calle* made me turn unconsciously from my course, and I found myself suddenly brought back to the Grand Canal. And as there is no great difference between the memory of a dream and the memory of reality, I ended by asking myself whether it was not during my sleep that there had occurred in a dark patch of Venetian crystallization that strange interruption which offered a vast piazza flanked by romantic palaces, to the meditative eye of the moon.

MARCEL PROUST
Remembrance of Things Past, 1925

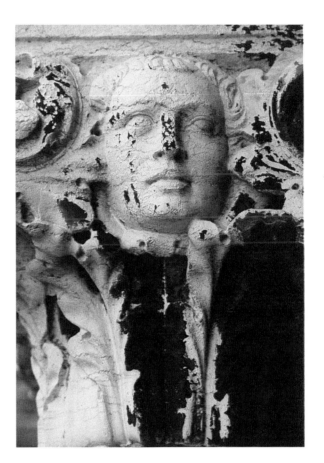

*On we went, floating towards the heart of this strange place –
with water all about us where never water was elsewhere –
clusters of houses, churches, heaps of stately buildings growing out
of it – and, everywhere, the same extraordinary silence.*

CHARLES DICKENS
An Italian Dream, 1844
At the height of his fame Dickens took a break from writing novels to travel in Italy for a year.
He was especially captivated by Venice and its dream-like qualities.

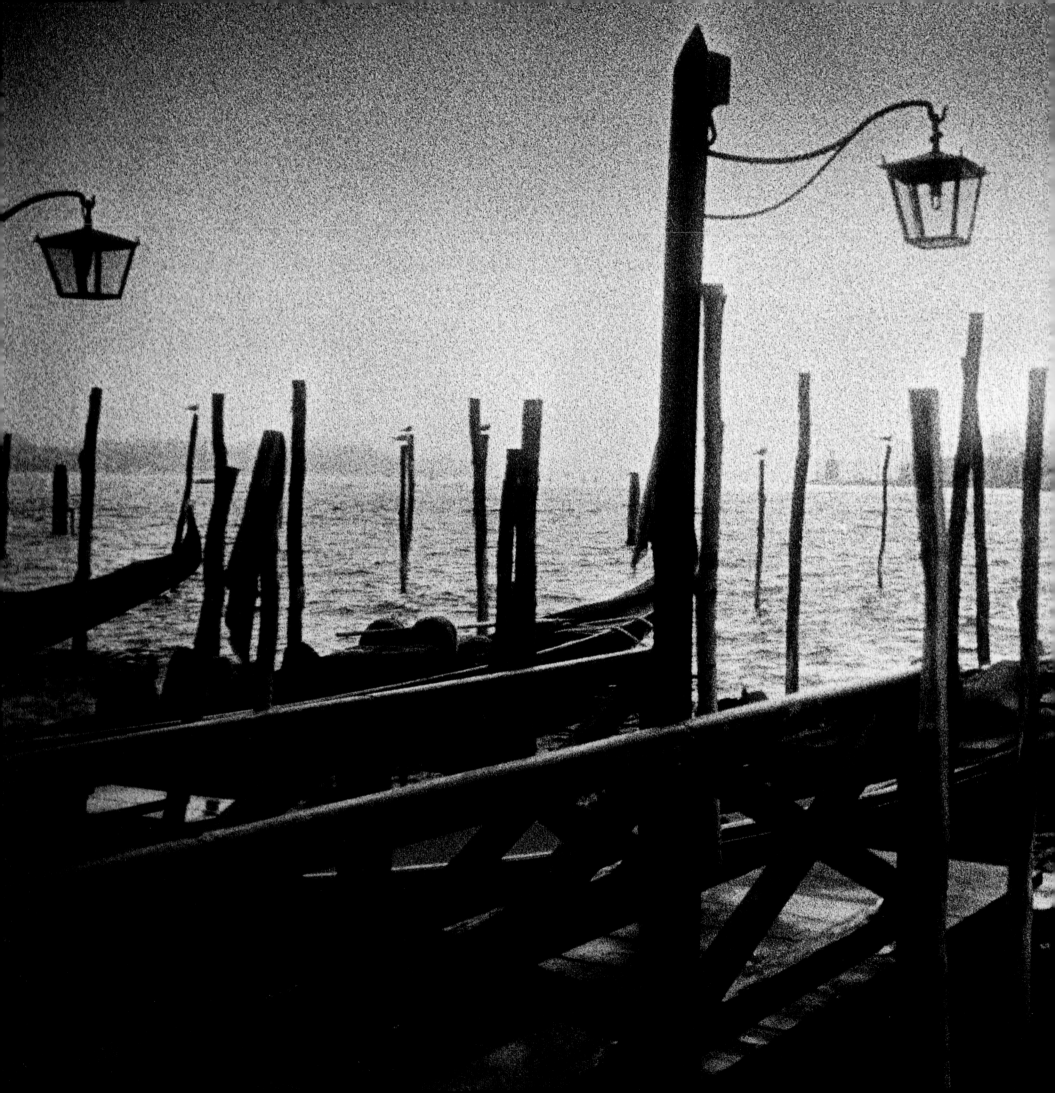

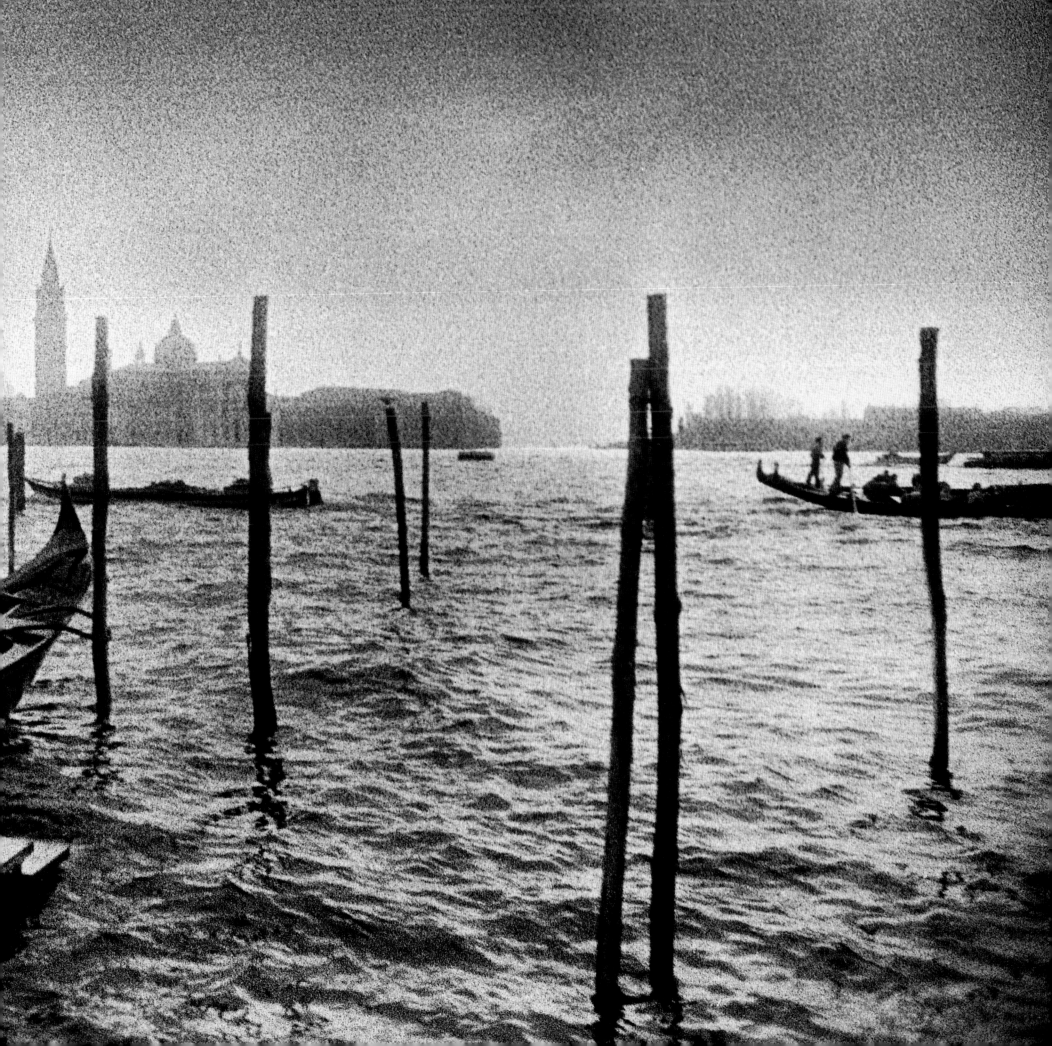

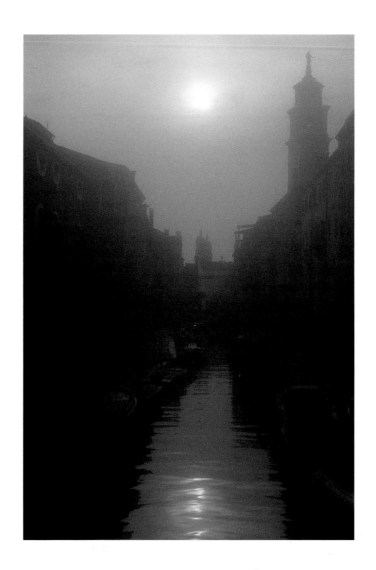

Before I knew by what, or how, I found we were gliding up a street – a phantom street; the houses rising on both sides, from the water, and the black boat gliding on beneath their windows. Lights were shining from some of these casements, plumbing the depth of the black stream with their reflected rays, but all was profoundly silent.

So we advanced into this ghostly city, continuing to hold our course through narrow streets and lanes, all filled and flowing with water. Some of the corners where our way branched off, were so acute and narrow, that it seemed impossible for the long slender boat to turn them; but the rowers, with a low melodious cry of warning, sent it skimming on without pause. Sometimes, the rowers of another black boat like our own, echoed the cry, and slackening their speed (as I thought we did ours) would come flitting past us like a dark shadow.

CHARLES DICKENS
An Italian Dream, 1844

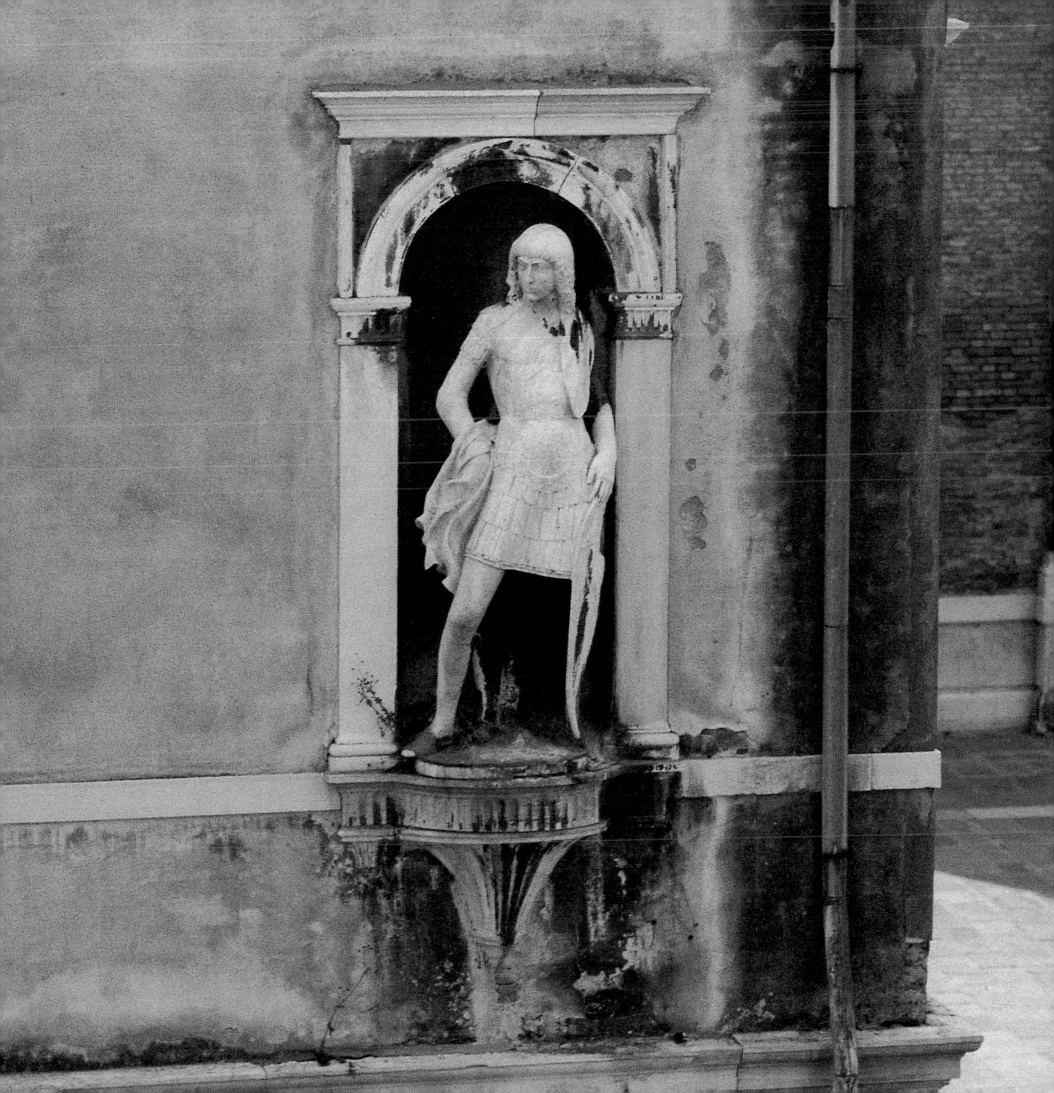

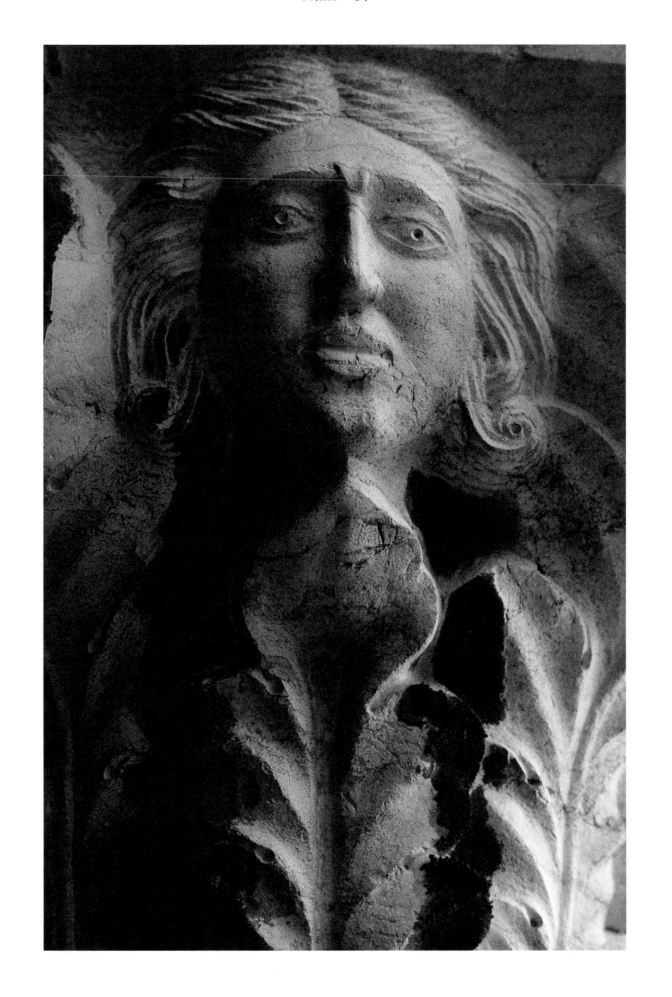

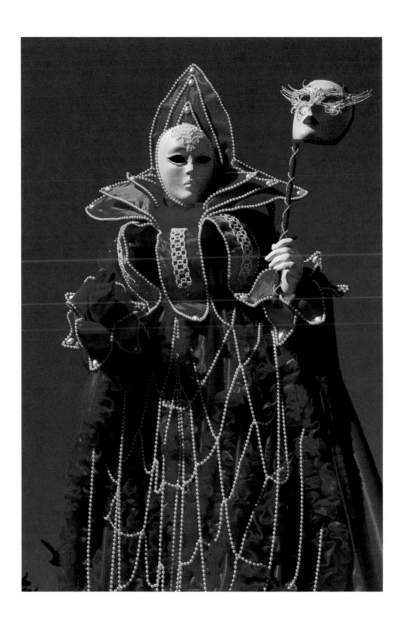

And at midnight we see the theatre break up and discharge its swarm of hilarious youth and beauty; we hear the cries of the hackman-gondoliers, and behold the struggling crowd jump aboard, and the black multitude of boats go skimming down the moonlit avenues; we see them separate here and there, and disappear up divergent streets; we hear the faint sounds of laughter and of shouted farewells floating up out the distance; and then, the strange pageant being gone, we have lonely stretches of glittering water – of stately buildings – of blotting shadows – of weird stone faces creeping into the moonlight – of deserted bridges – of motionless boats at anchor. And over all broods that mysterious stillness, that stealthy quiet, that befits so well this old dreaming Venice . . .

MARK TWAIN
The Innocents Abroad, 1867

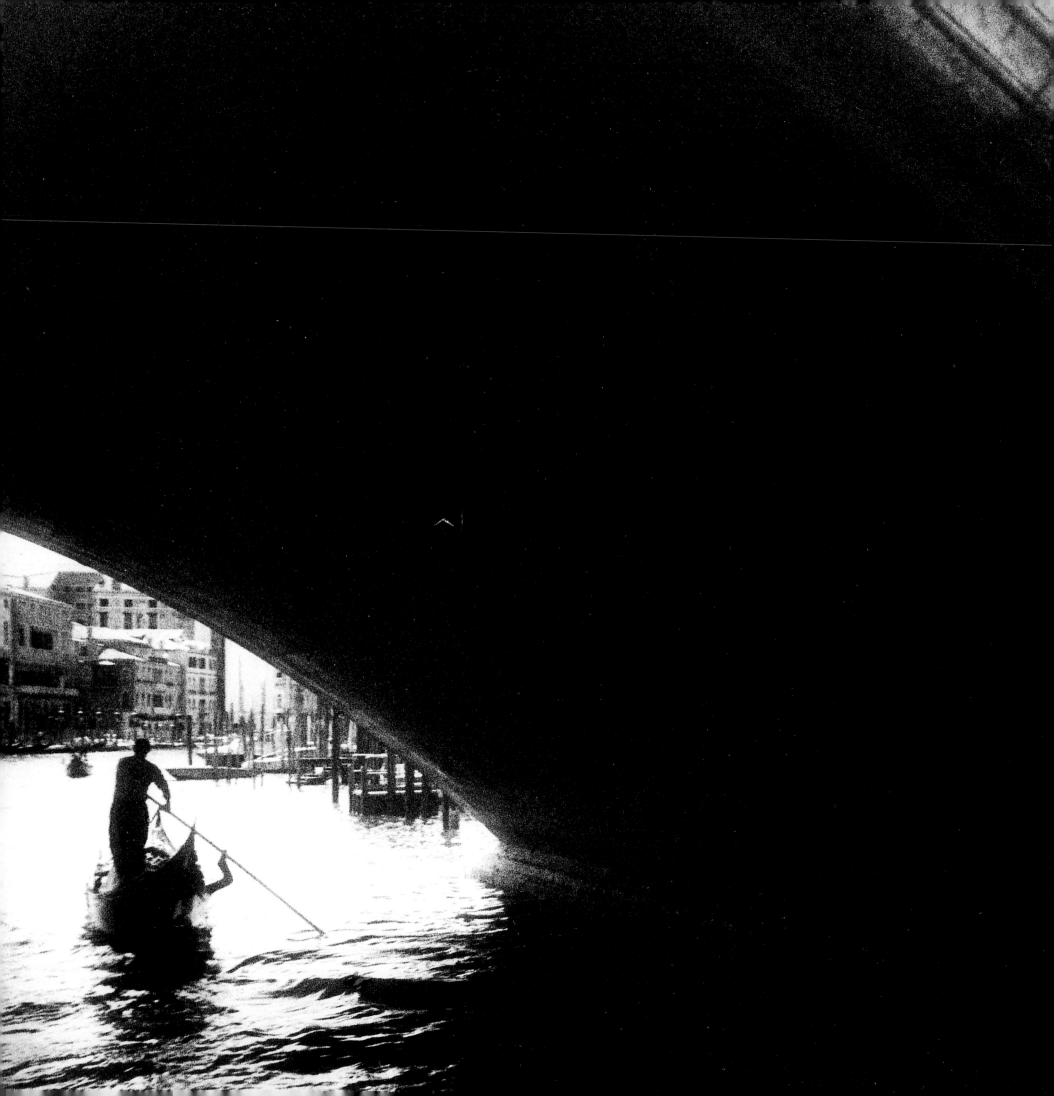

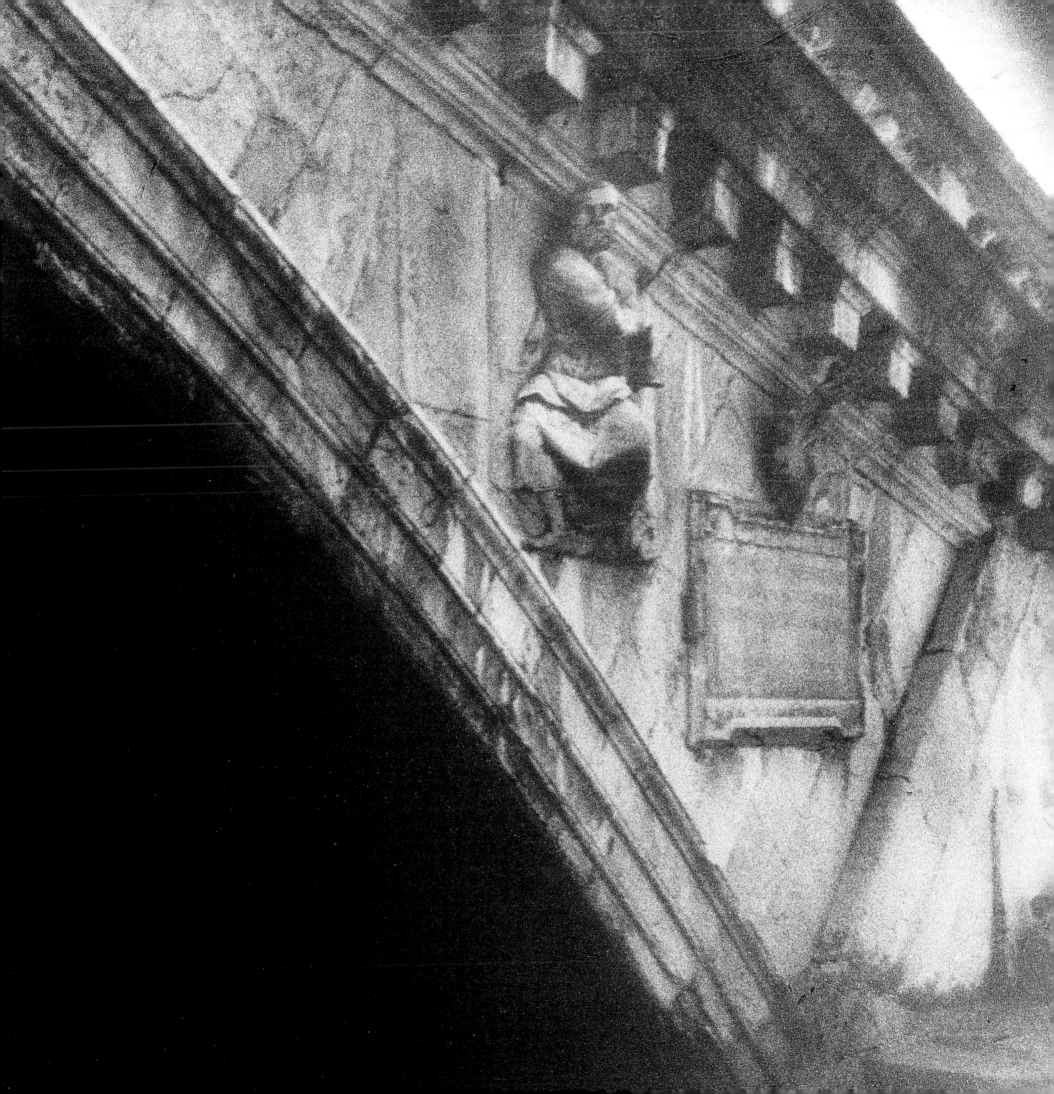

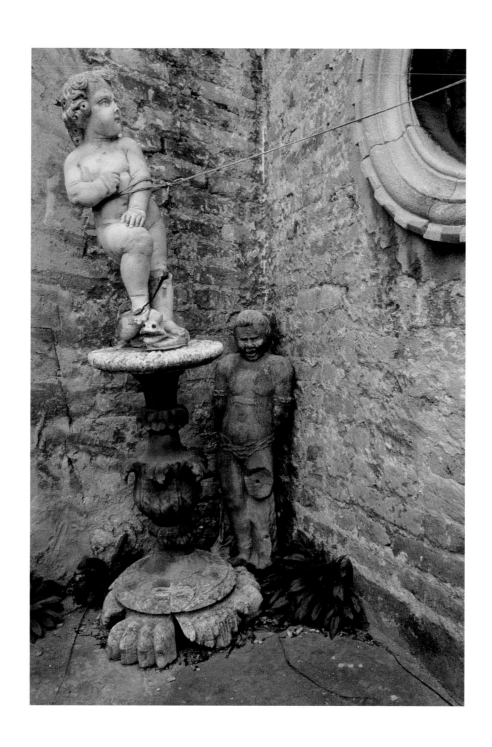

𝒜ll the forgotten diseases of the leproseries of the Orient seemed to gnaw these blistered walls.

THÉOPHILE GAUTIER

'Voyage en Italie', from *The Complete Works*, Vol. IV, 1901

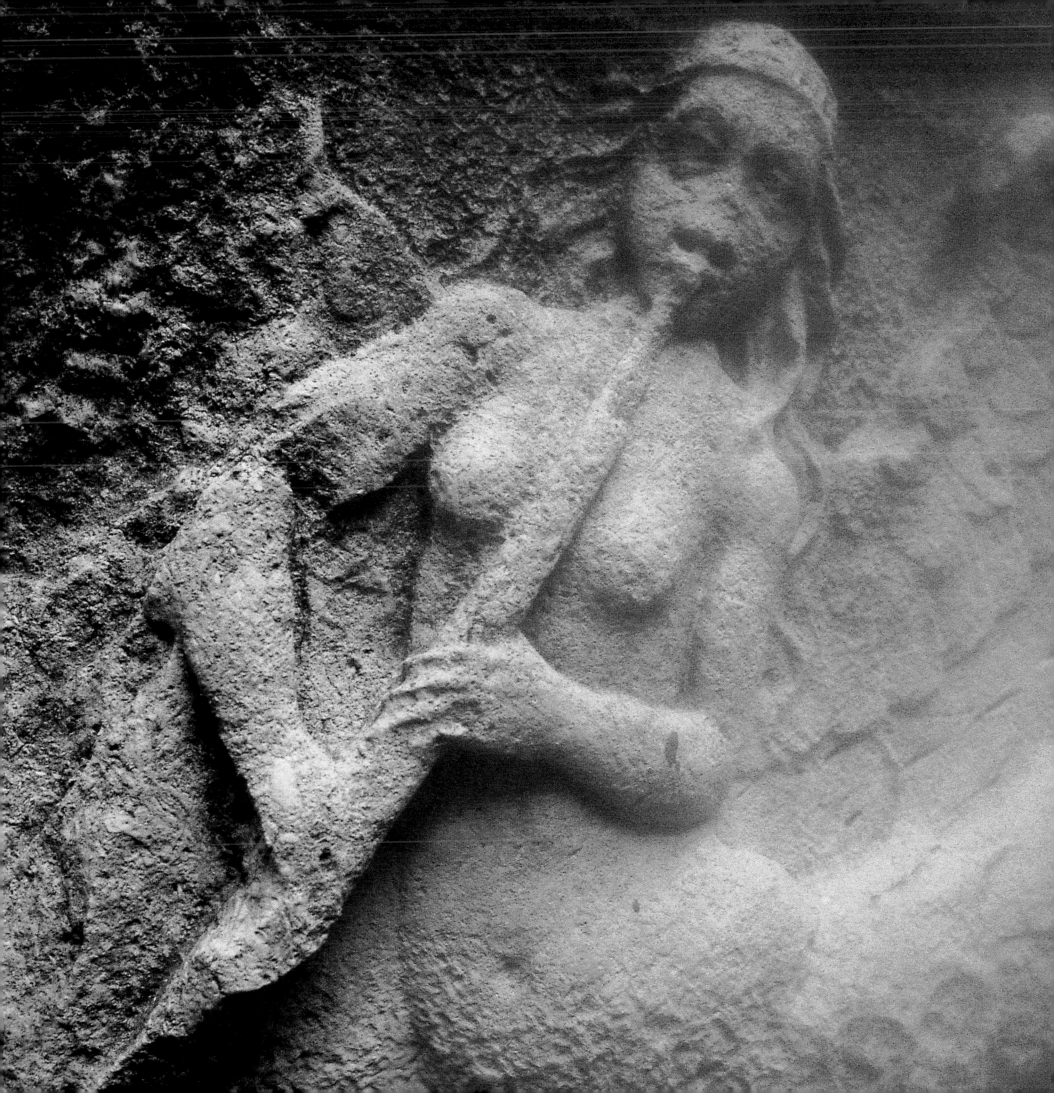

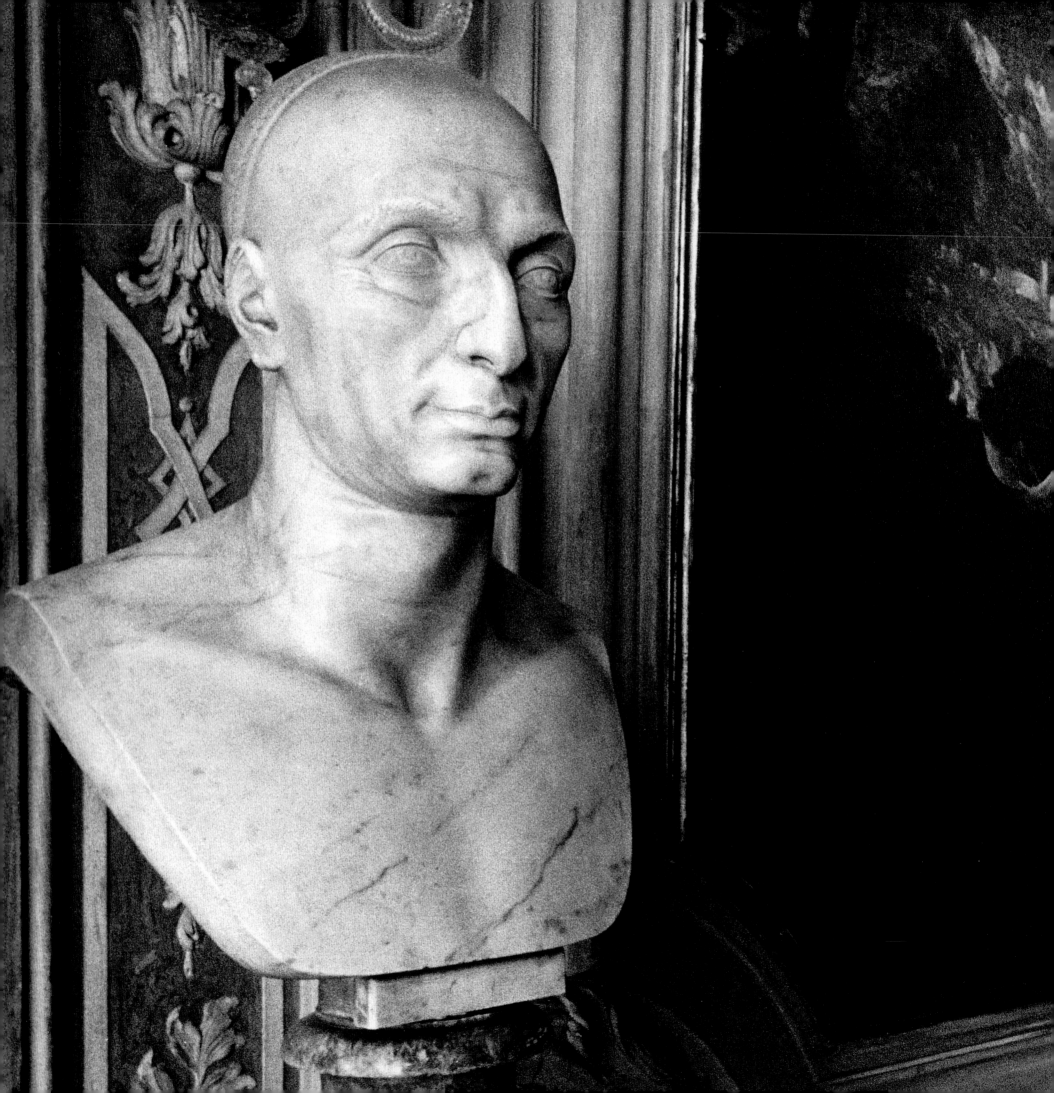

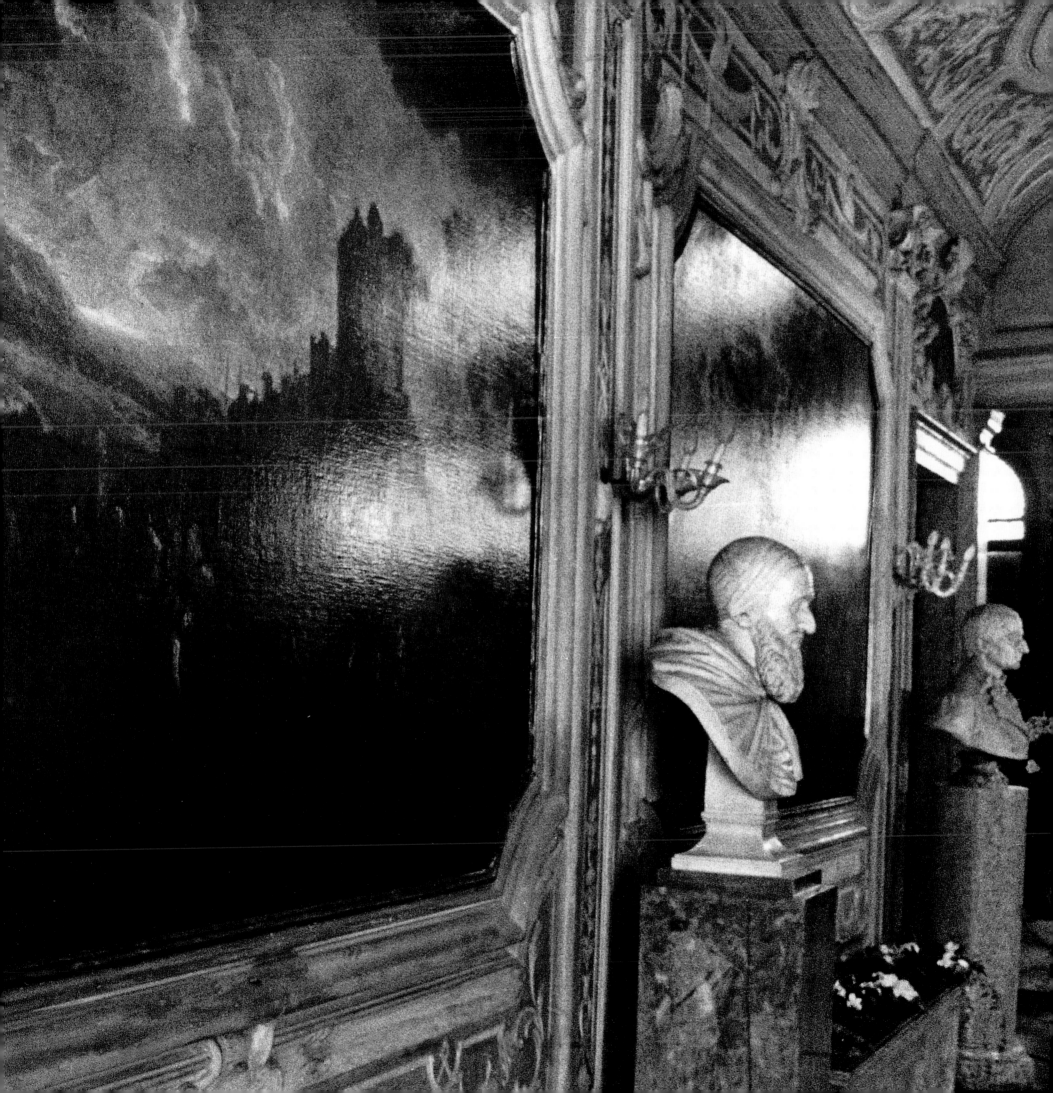

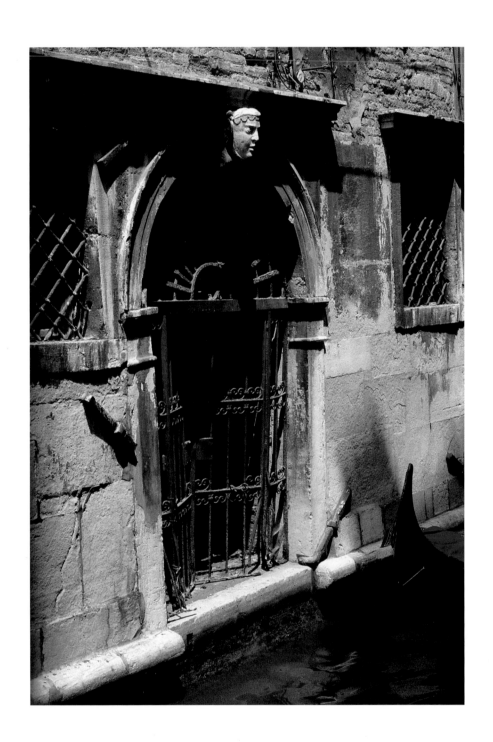

*A*bhorrent green, slippery city, whose Doges were old, and had ancient eyes.

D.H. LAWRENCE

'Pomegranate', from *Birds, Beasts and Flowers*, 1923

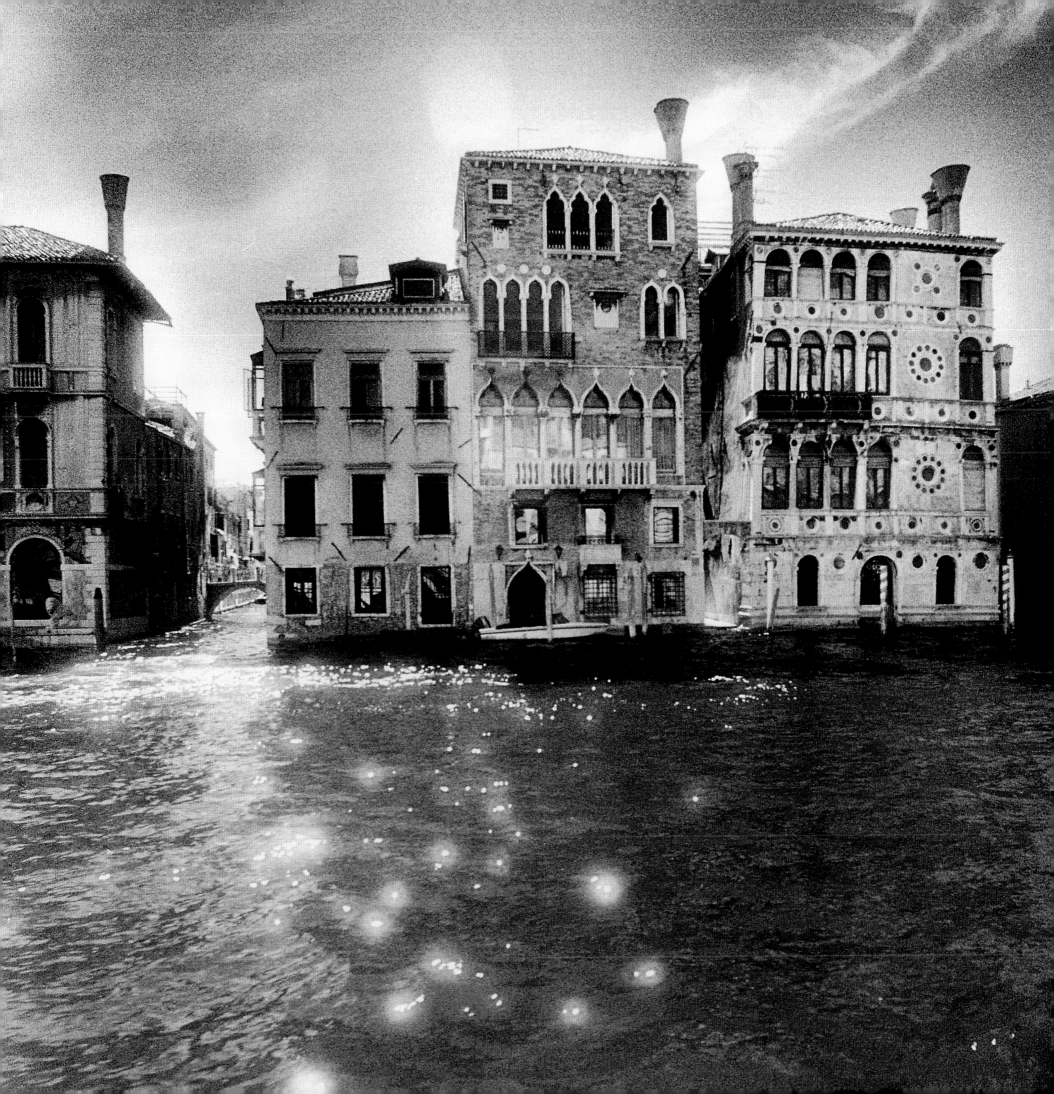

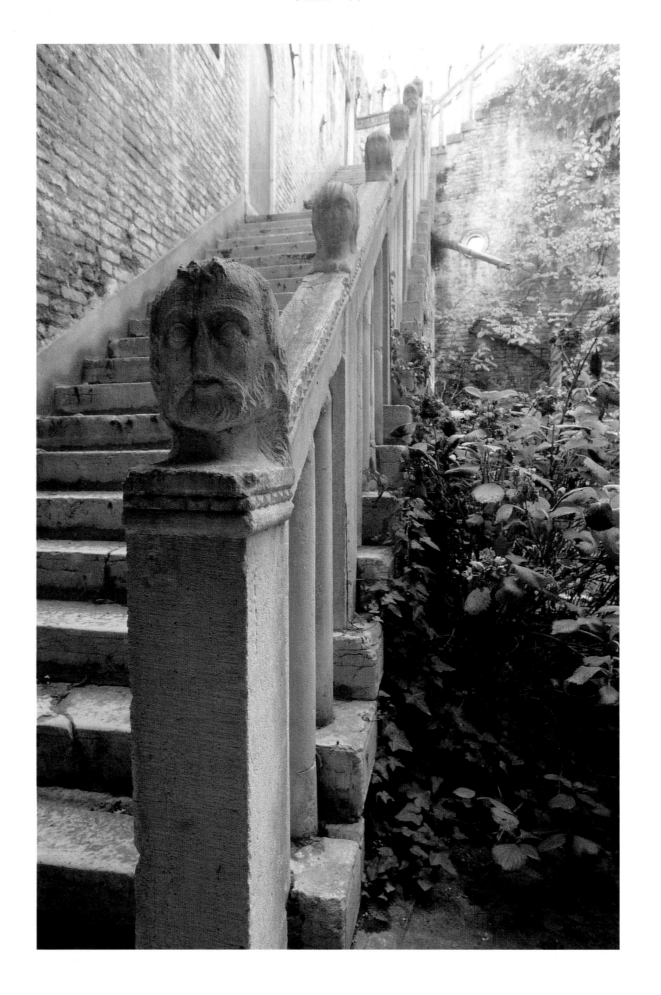

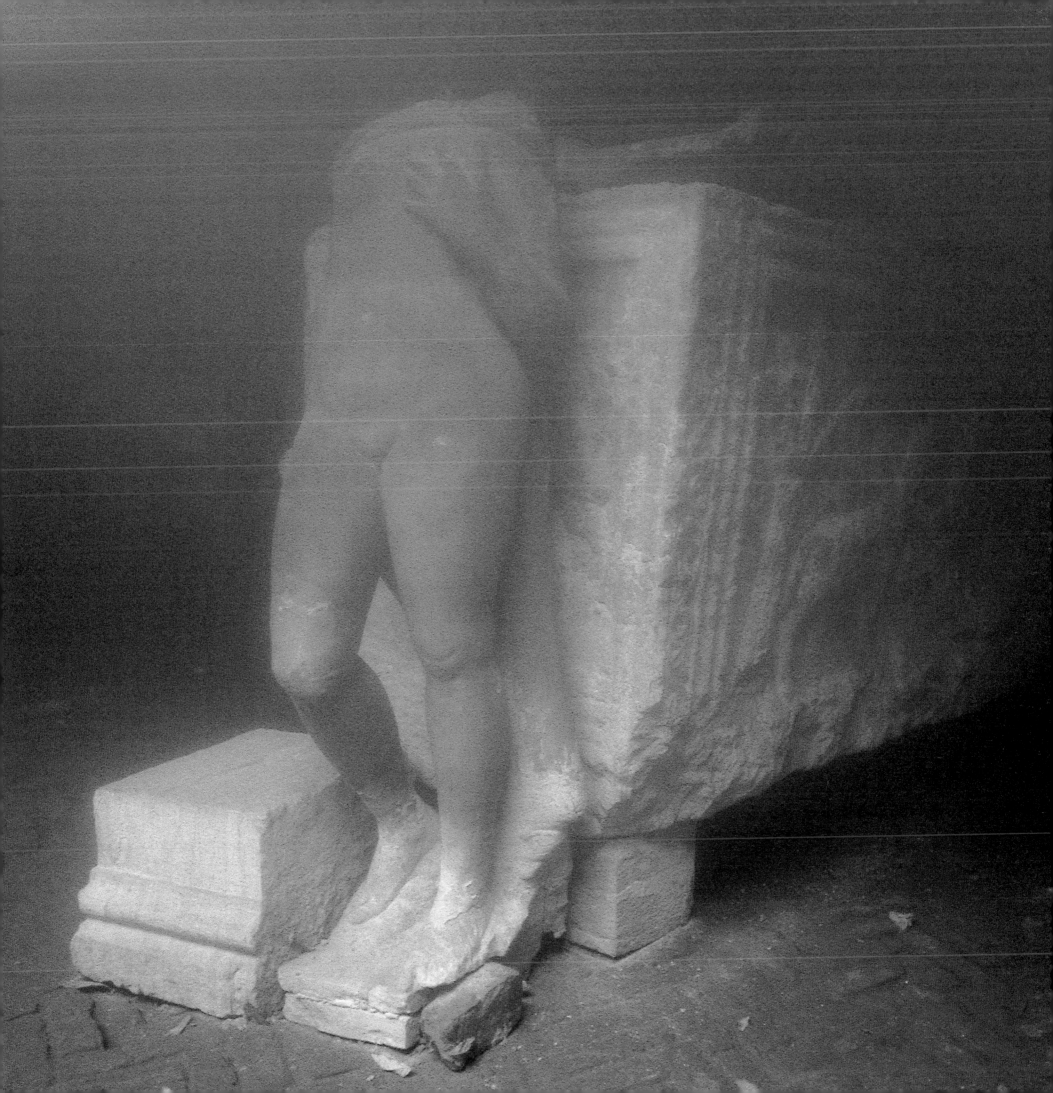

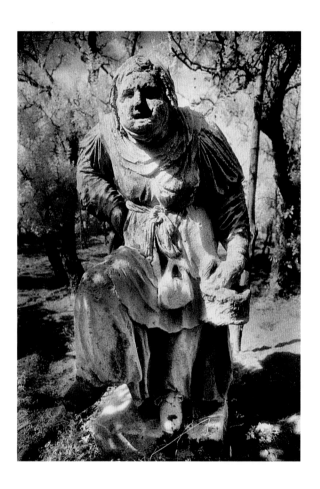
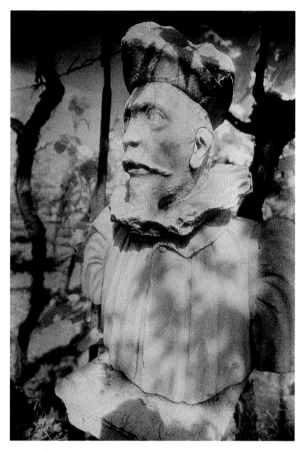

o the Venetians became islanders, and islanders they remain, still a people apart, still tinged with the sadness of refugees. The squelchy islands of their lagoon, welded over the centuries into a glittering Republic, became the greatest of trading States, mistress of the eastern commerce and the supreme naval power of the day. For more than a thousand years Venice was something unique among the nations, half eastern, half western, half land, half sea, poised between Rome and Byzantium, between Christianity and Islam, one foot in Europe, the other paddling in the pearls of Asia. She called herself the Serenissima, she decked herself in cloth of gold, and she even had her own calendar, in which the years began on March 1st, and the days began in the evening. This lonely hauteur, exerted from the fastnesses of the lagoon, gave to the old Venetians a queer sense of isolation. As their Republic grew in grandeur and prosperity, and their political arteries hardened, and a flow of dazzling booty enriched their palaces and churches, so Venice became entrammelled in mystery and wonder. She stood, in the imagination of the world, somewhere between a freak and a fairy tale.

JAMES MORRIS
Venice, 1960

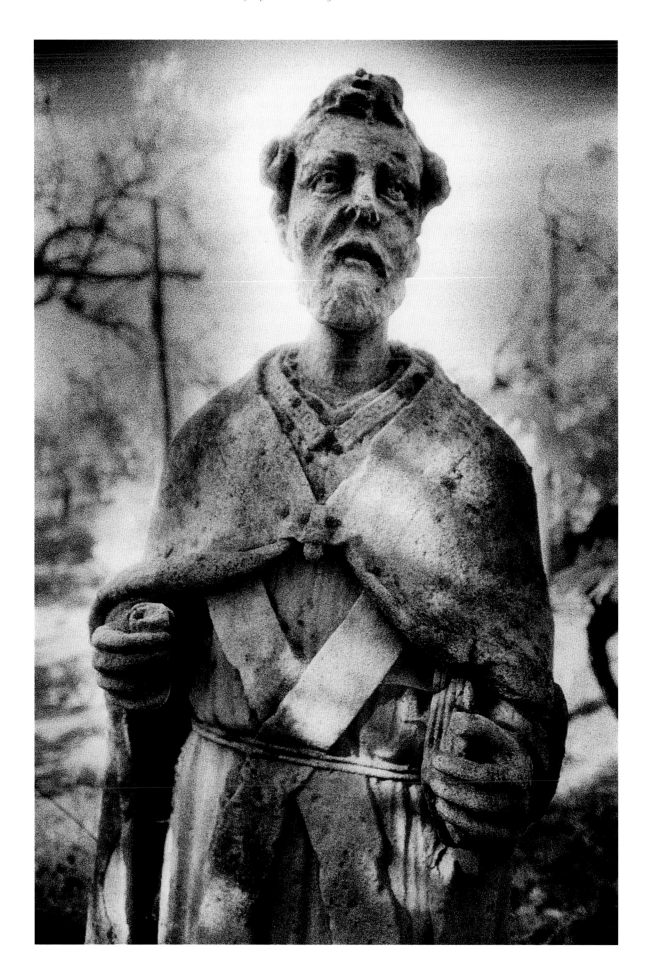

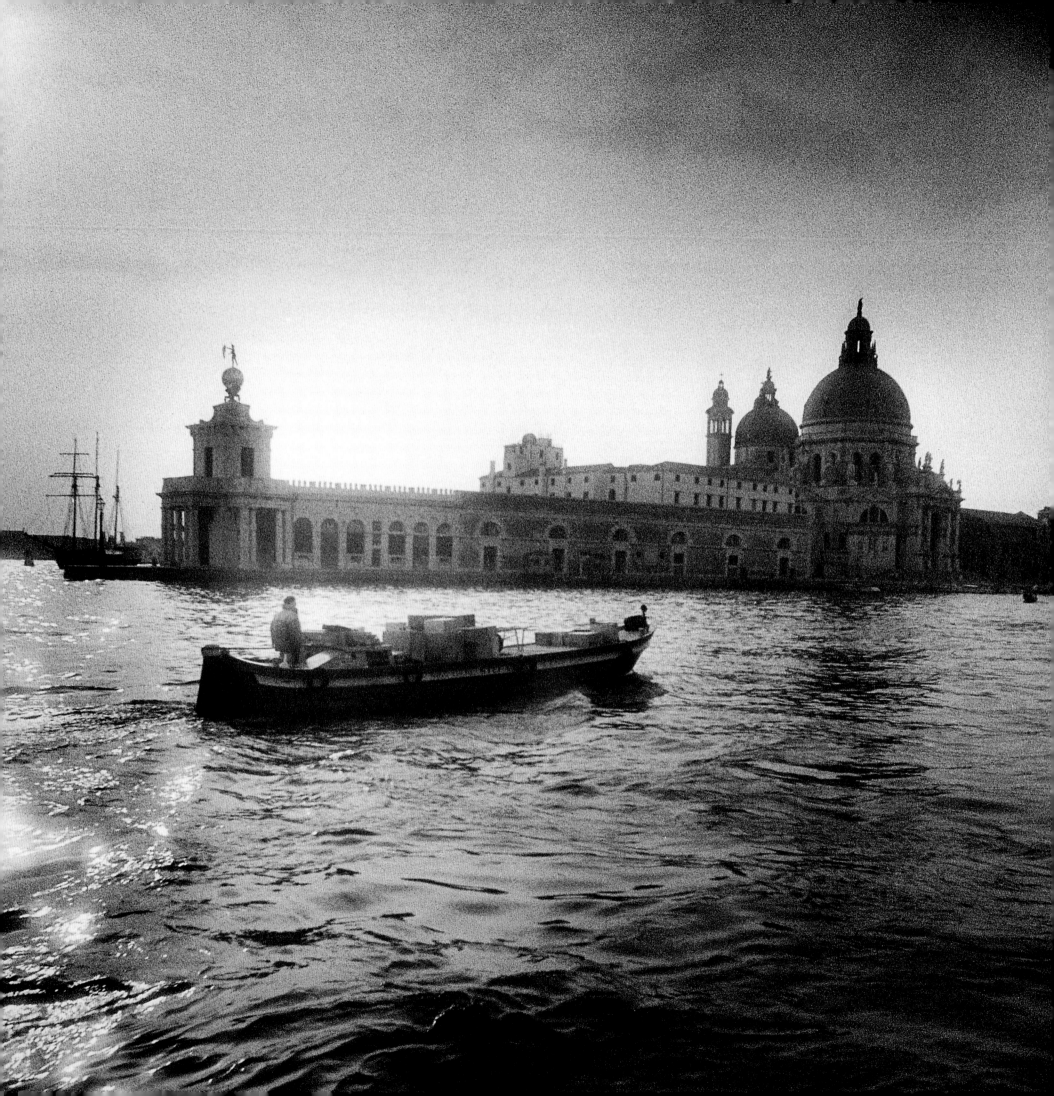

. . . I love all waste

And solitary places; where we taste

The pleasure of believing what we see

Is boundless, as we wish our souls to be . . .

P.B. SHELLEY

'Julian and Maddalo', from *Posthumous Poems*, 1824

The poem is set in Venice; a philosophical conversation between Shelley (Julian) and Byron (Maddalo).

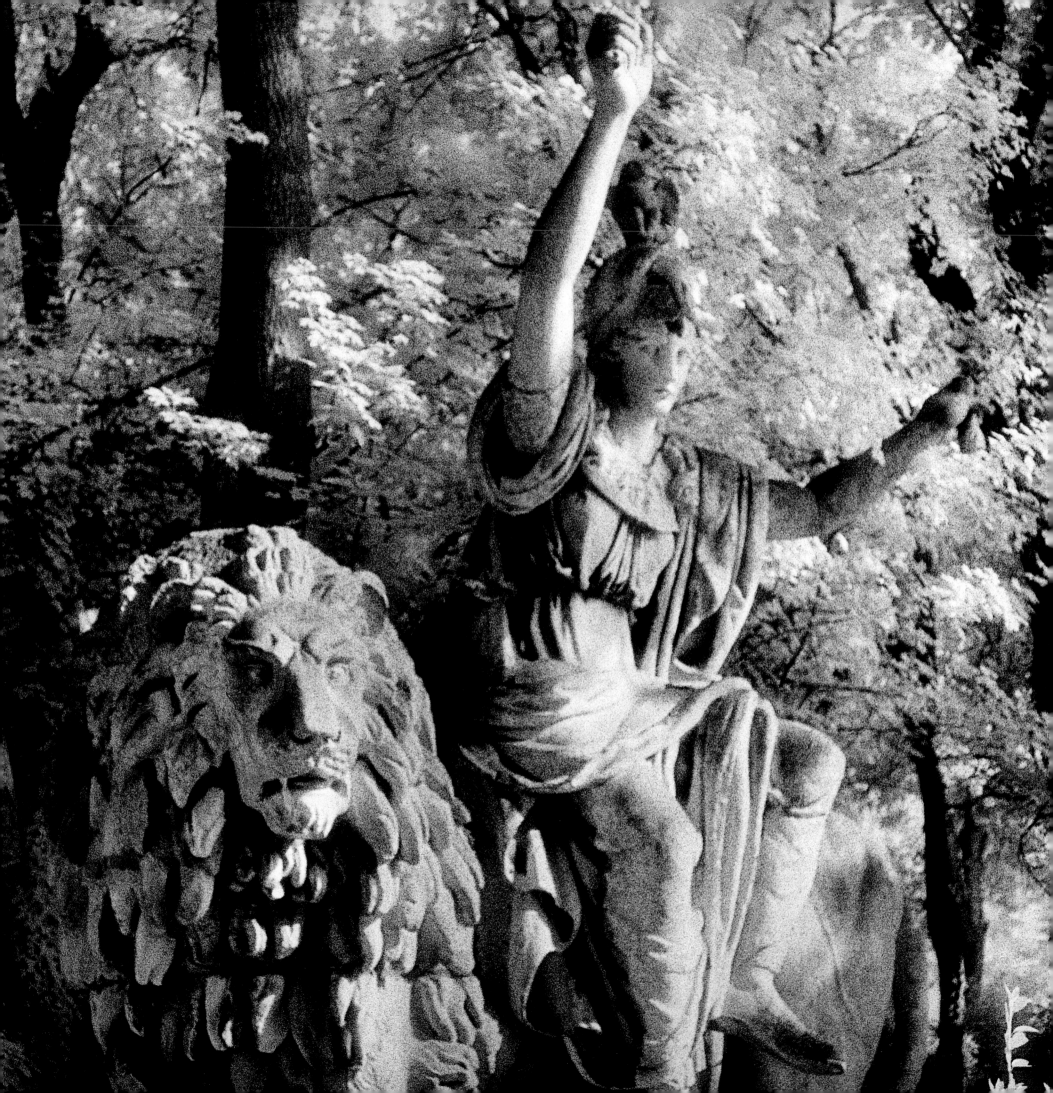

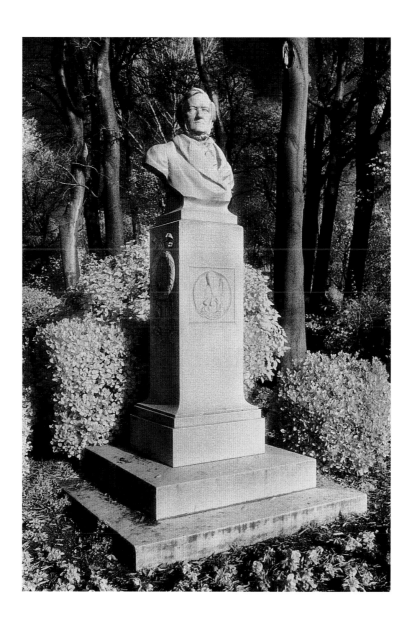

I arrived in Venice on the afternoon of 29 August (1858). On the journey to St Mark's Square along the Grand Canal, melancholy impressions, gloomy and reflective mood: grandeur, beauty and decline before one's eyes all at the same time. I was, on the other hand, comforted to realise that there is no sign of the prosperity of our times here, and therefore no vulgar commercialism. Piazza San Marco looked like a scene from a fairy tale. An absolutely faraway world from another age: everything in excellent harmony with my desire for solitude. Nothing here seems to be in direct contact with real life; everything gives the objective impression of a work of art. I want to stay here – and I will stay . . .

RICHARD WAGNER
Venetian Diary, 1858

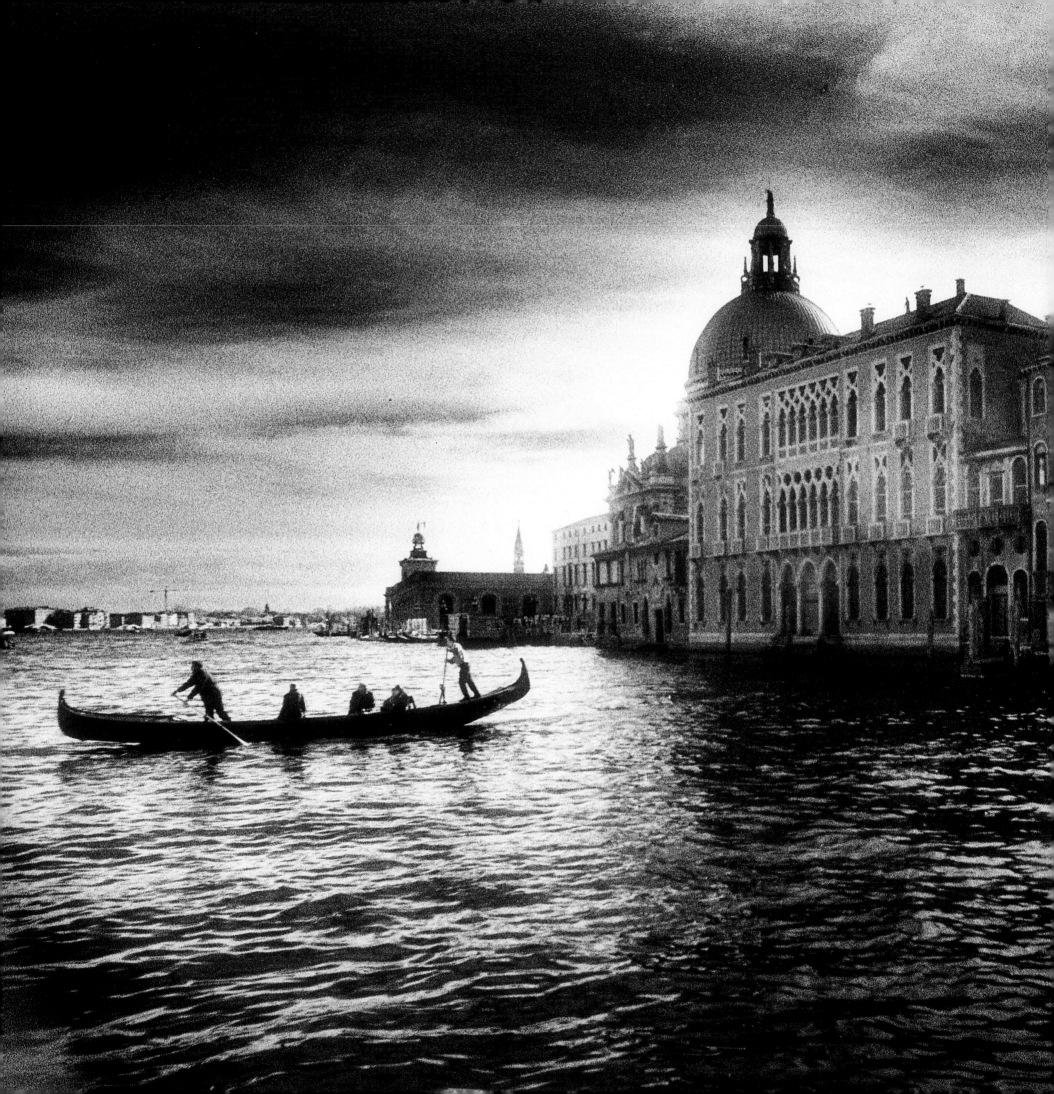

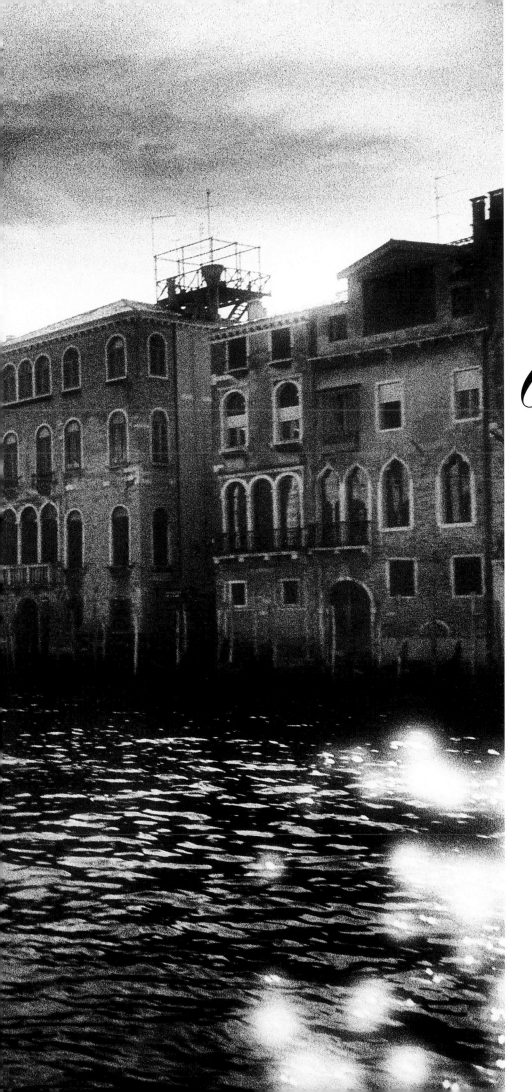

On a sleepless night that drove me out on the balcony of my apartment at about three o'clock in the morning, I heard for the first time the famous old folksong of the gondolieri. I thought the first call, piercing the stillness of the night like a harsh lament, emanated from the Rialto, barely a quarter hour's distance away, or thereabouts; from a similar distance this would be answered from another quarter in the same way. This strange melancholy dialogue, which was repeated frequently at longish intervals, moved me too much for me to be able to fix its musical components in my mind. Yet on another occasion I learned that this folksong had an indisputably poetic interest. When I was riding back late one evening along the dark canal, the moon came out and illuminated, together with the indescribable palaces, the tall silhouette of my gondolier towering above the stern of his gondola, while he slowly turned his mighty oar. Suddenly from his breast came a mournful sound not unlike the howl of an animal, swelling up from a deep, low note, and after a long-sustained 'Oh', it culminated in the simple musical phrase 'Venezia'. This was followed by some words I could not retain in my memory, being so greatly shaken by the emotion of the moment. Such were the impressions that seemed most characteristic of Venice to me during my stay, and they remained with me until the completion of the second act of Tristan, and perhaps even helped to inspire the long-drawn-out lament for the shepherd's horn at the beginning of the third act.

RICHARD WAGNER
from *My Life*, 1911, translated by Andrew Gray.
Richard Wagner died in the Palazzo Vendramin Calergi, 13 February 1883.

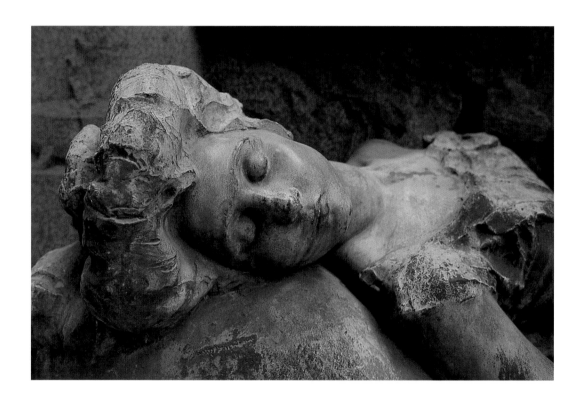

Sleep, Venice, sleep! the evening gun resounds
Over the waves that rock thee on their breast;
The bugle blare to kennel calls the hounds,
Who sleepless watch thy waking and thy rest.

Sleep till the night stars do the day star meet,
And shuddering echoes o'er the water run,
Rippling thro' every glass-green wavering street
The stern good-morrow of thy guardian Hun.

Still do thy stones, O Venice, bid rejoice
With their old majesty the gazer's eye,
In their consummate grace uttering a voice
From every line of blended harmony.

Still glows the splendour of each wondrous dream
Vouchsaf'd thy painters o'er each sacred shrine,
And from the radiant visions downward streams
In visible light an influence divine.

FANNY KEMBLE
Poems, 1883

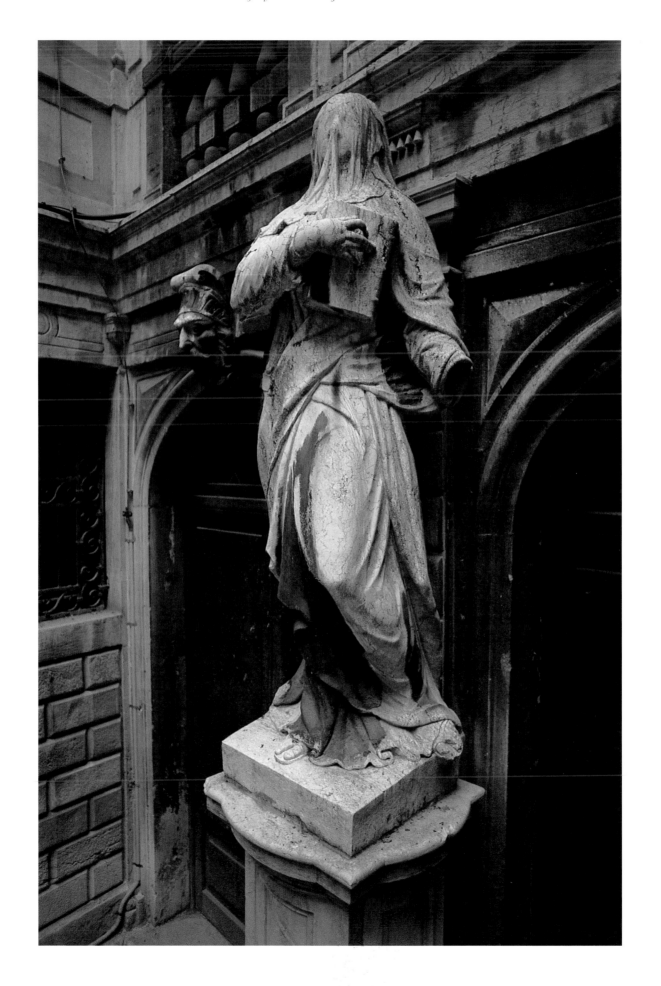

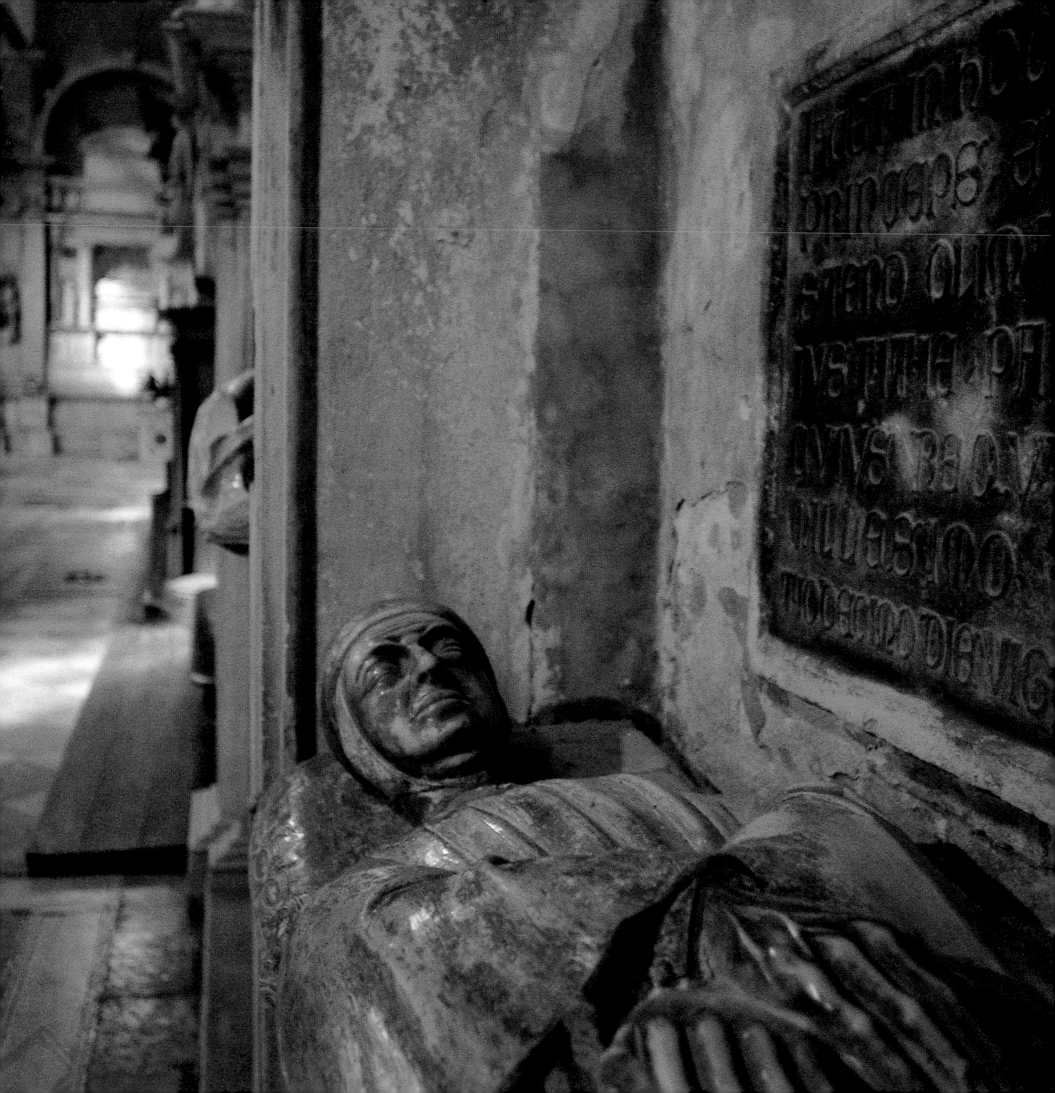

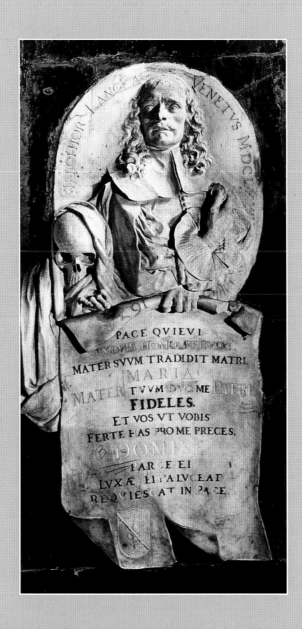

We have seen, in these old churches, a profusion of costly and elaborate sepulchre ornamentation such as we never dreamt of before. We have stood in the dim religious light of these hoary sanctuaries, in the midst of long ranks of dusty monuments and effigies of the great dead of Venice, until we seemed drifting back, back, back, into the solemn past, and looking upon the scenes and mingling with the peoples of a remote antiquity. We have been in a half-waking sort of dream all the time. I do not know how else to describe the feeling. A part of our being has remained still in the nineteenth century, while another part of it seemed in some unaccountable way walking among the phantoms of the tenth.

MARK TWAIN
The Innocents Abroad, 1867

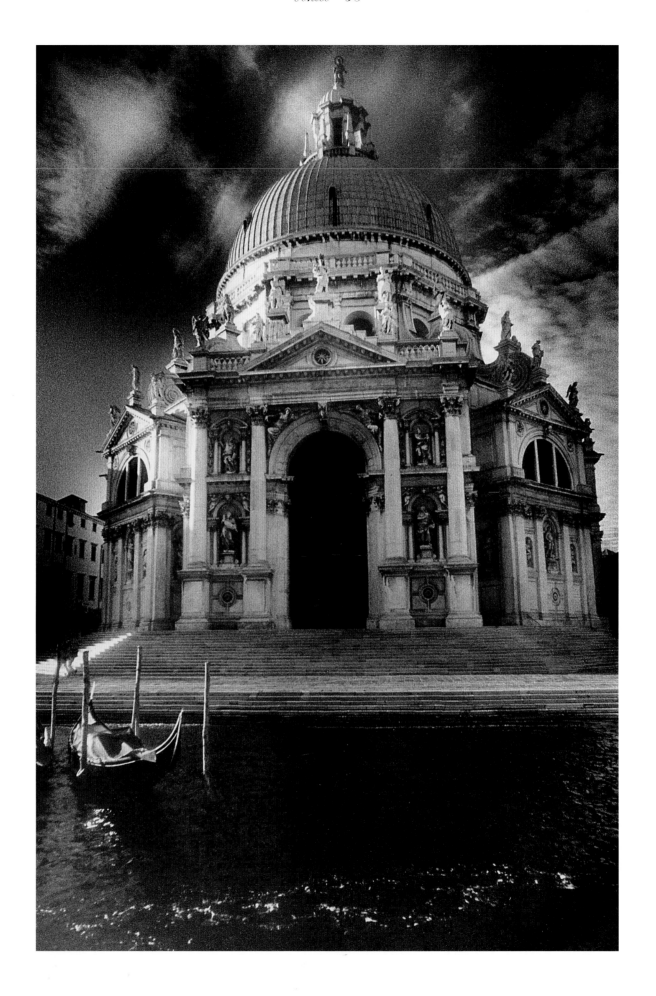

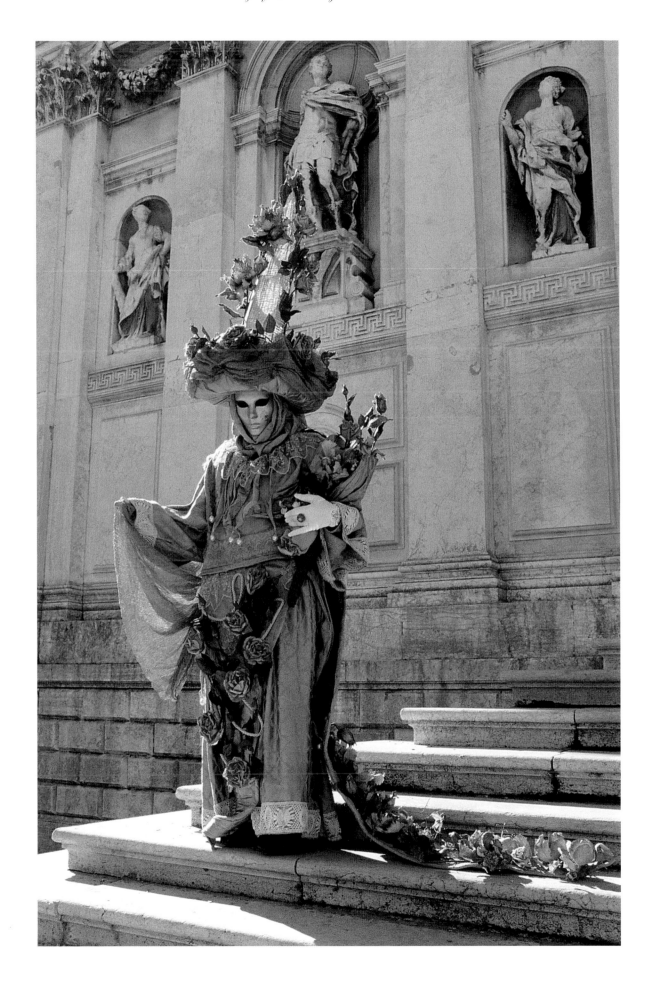

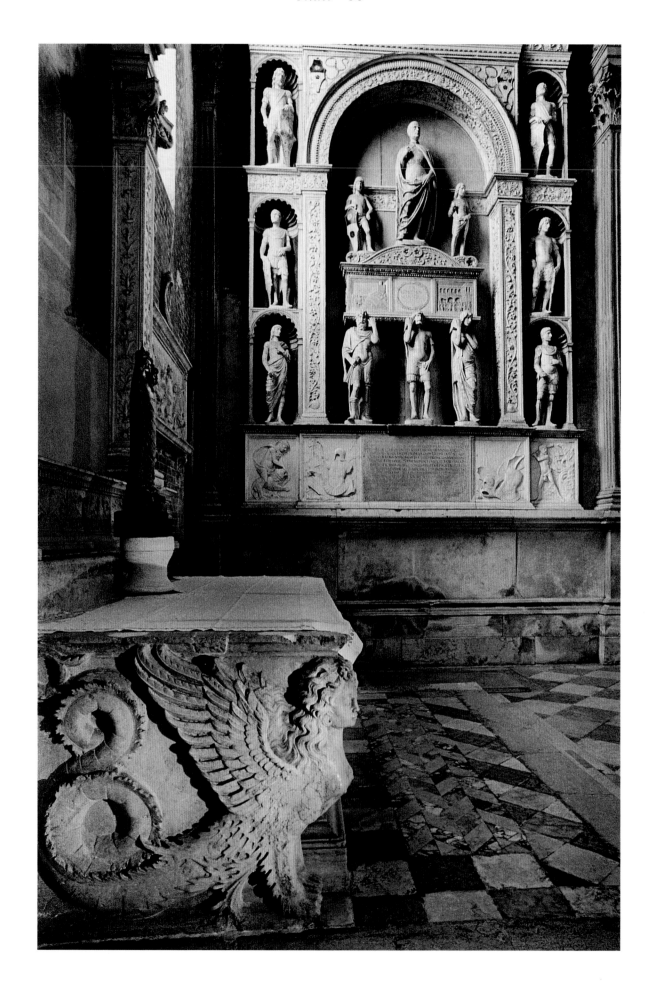

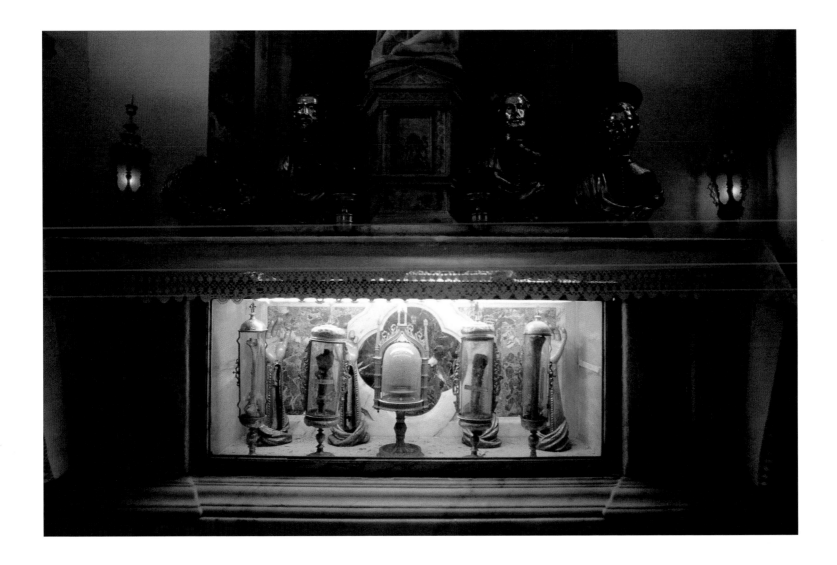

Sometimes, alighting at the doors of churches and vast palaces, I wandered on, from room to room, from aisle to aisle, through labyrinths of rich altars, ancient monuments; decayed apartments where the furniture, half awful, half grotesque, was mouldering away. Pictures were there, replete with such enduring beauty and expression: with such passion, truth and power: that they seemed so many young and fresh realities among a host of spectres. I thought these, often intermingled with the old days of the city: with its beauties, tyrants, captains, patriots, merchants, courtiers, priests: nay, with its very stones and bricks, and public places; all of which lived again, about me, on the walls. Then, coming down some marble staircase where the water lapped and oozed against the lower steps, I passed into my boat again, and went on in my dream.

CHARLES DICKENS
An Italian Dream, 1844

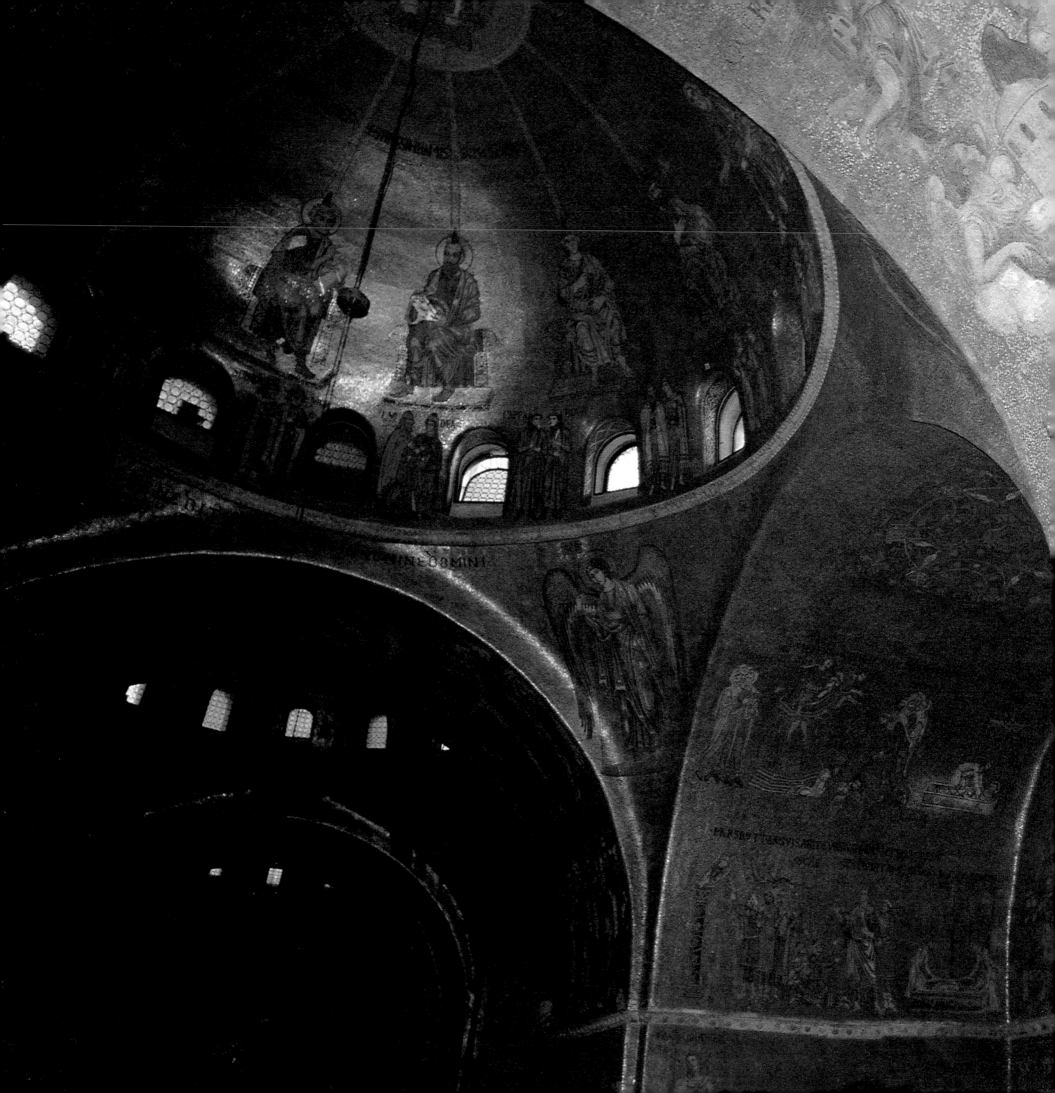

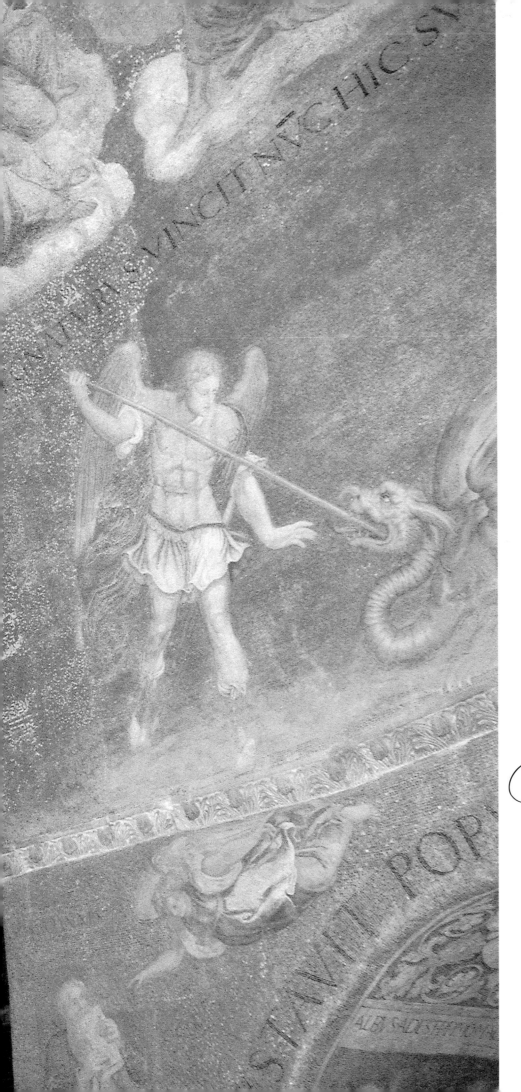

I thought I entered the Cathedral, and went in and out
among its many arches: traversing its whole extent. A grand
and dreamy structure, of immense proportions; golden with old
mosaics; redolent of perfumes; dim with the smoke of incense; costly
in treasure of precious stones and metals, glittering through iron bars;
holy with the bodies of deceased saints; rainbow-hued with windows of
stained glass; dark with carved woods and coloured marbles; obscure
in its vast heights, and lengthened distances; shining with silver lamps
and winking lights; unreal, fantastic, solemn, inconceivable throughout.

CHARLES DICKENS
An Italian Dream, 1844

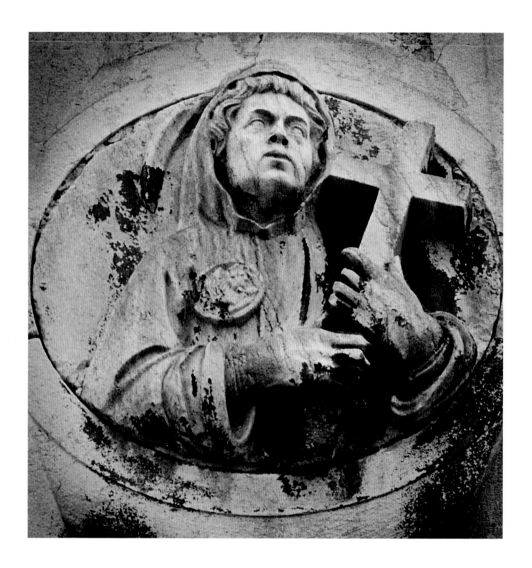

He went, every evening, to the sermon and benediction at the church of the Gesuati on the Zattere: first to pay the prodigious debt of the present to the past – the duty of love and piety to the dead; and, second, for the sake of an hour in quiet sheltered obscurity. The grand temple, prepared for the Month of the Dead, draped in silver and black, with its forest of slim soaring tapers crowned with primrose stars in mid-air half-way up the vault, and the huge glittering constellation aloft in the apse where God in His Sacrament was enthroned, replenished his beauty-worshipping soul with peace and bliss. The patter of the preacher passed him unheard. His wordless prayer, for eternal rest in the meanest crevice of purgatory, poured forth unceasingly with the prayers of the dark crowd kneeling with him in the dimness below.

FREDERICK ROLFE (BARON CORVO)
The Desire and the Pursuit of the Whole: A Romance of Modern Venice, 1909

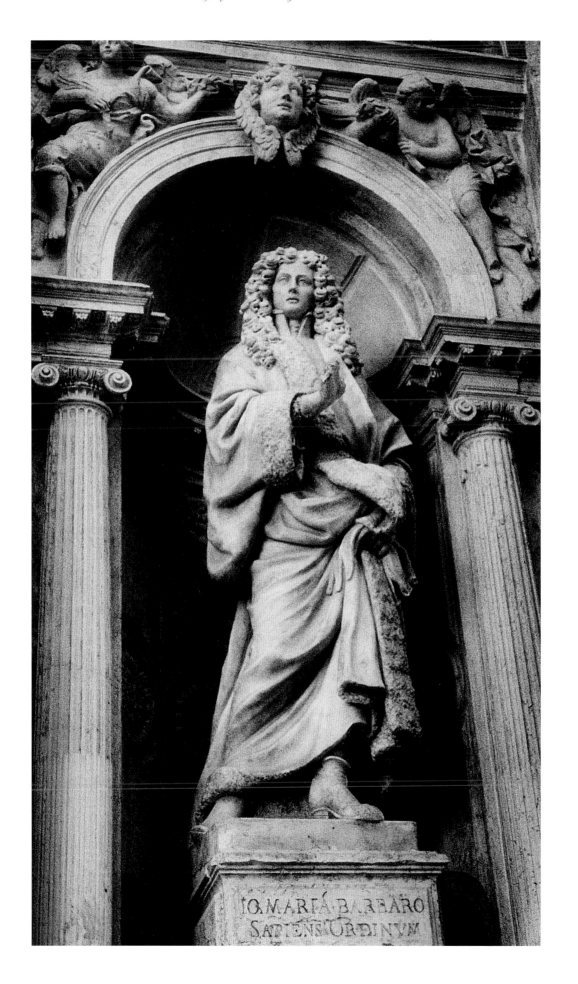

IO. MARIA BARBARO
SAPIENS ORDINVM

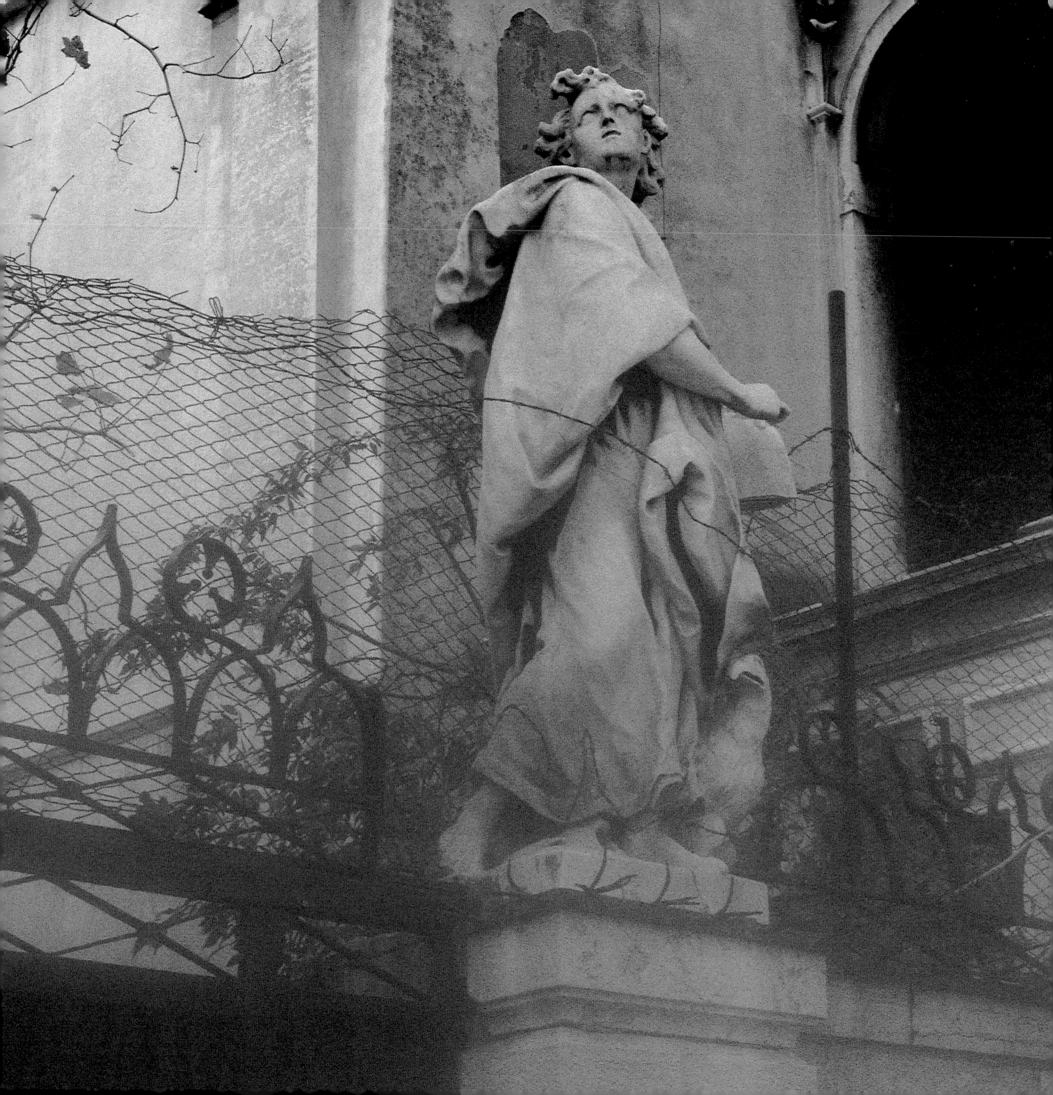

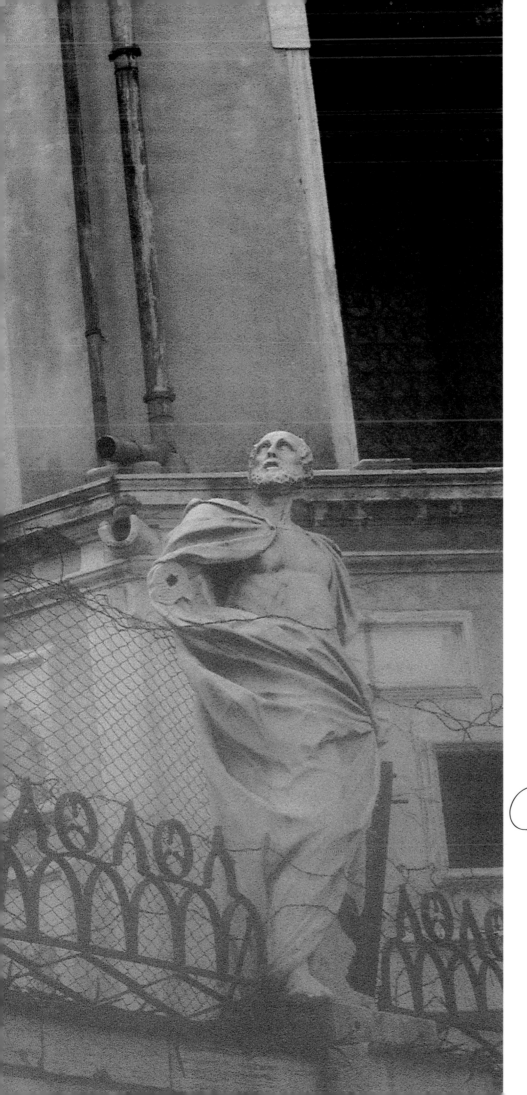

Sometimes I came upon a great palace half in ruins, faintly showing in the shadows, thanks to a silvery beam; the panes left in its broken windows gleaming suddenly like scales or mirrors; now a bridge tracing its black arch against a stretch of bluish water over which floated a light mist; farther on a trail of red fire, falling from a lighted house upon the oily darkness of a sleeping canal; at other times a deserted square on which stood out quaintly the top of a church covered with statues which in obscurity looked like spectres . . .

THÉOPHILE GAUTIER
'Voyage en Italie', from *The Complete Works*, Vol. IV, 1901

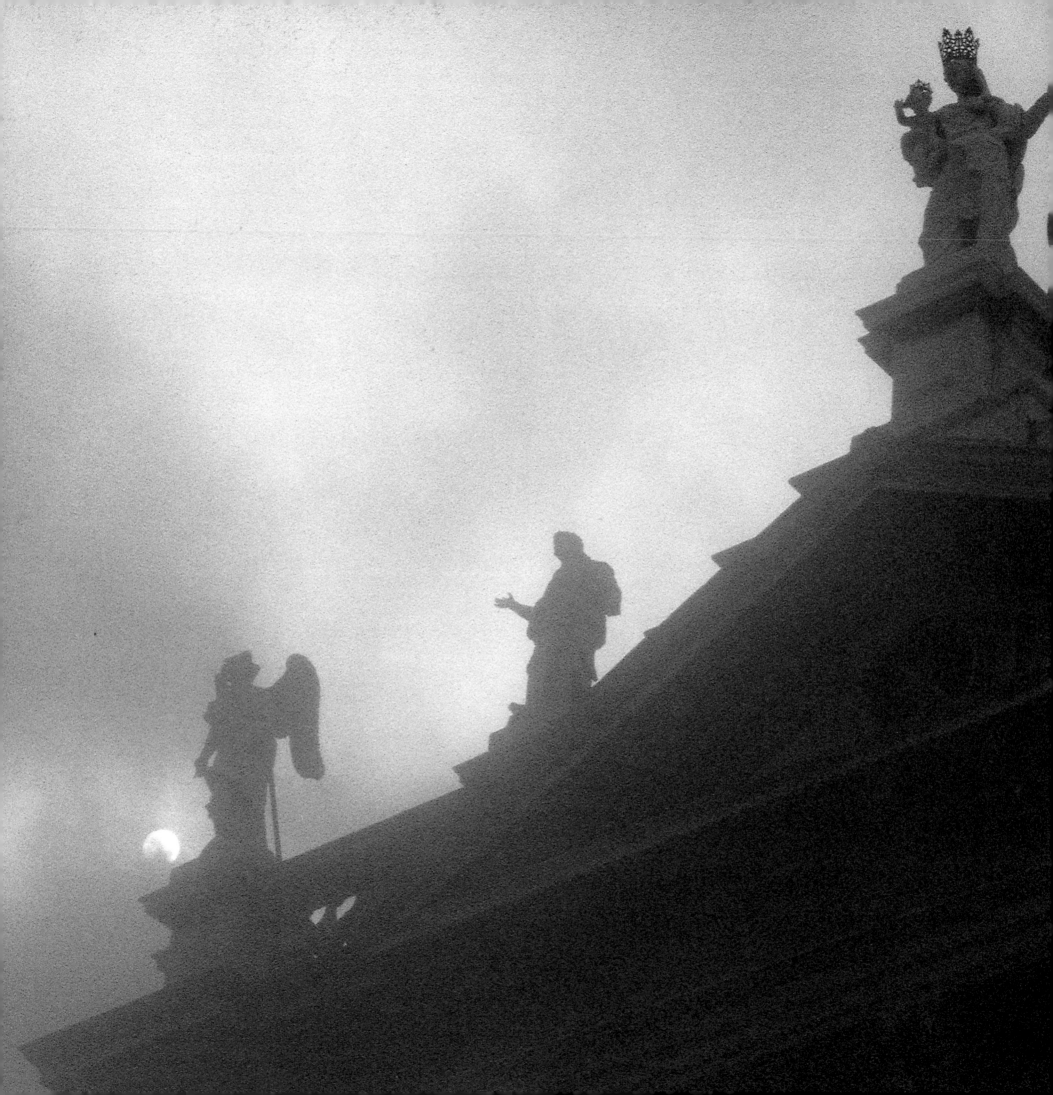

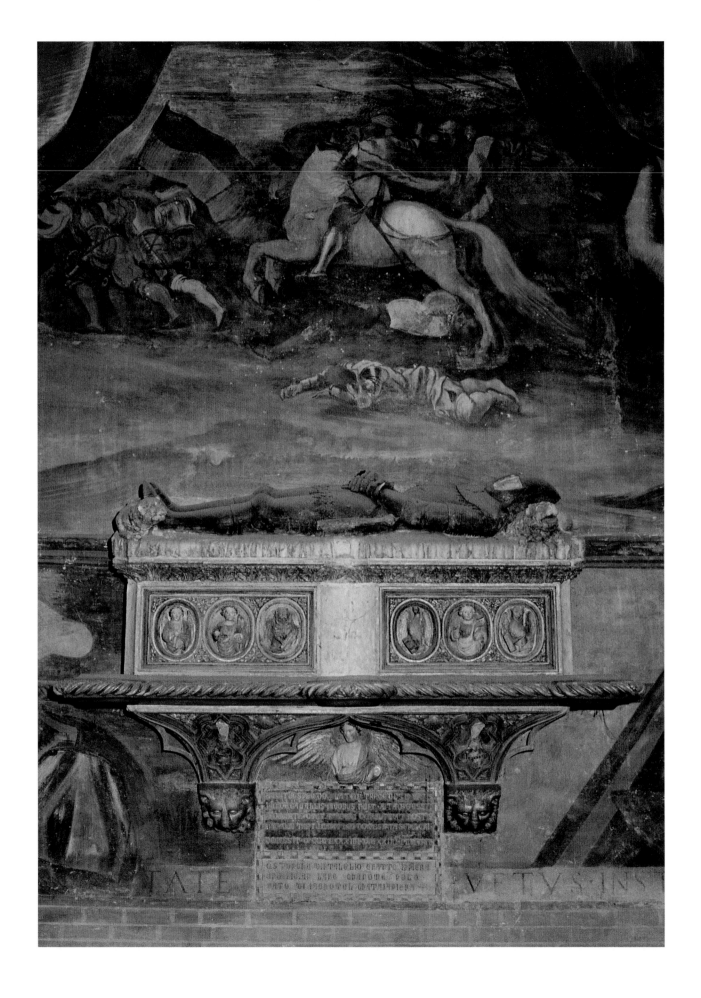

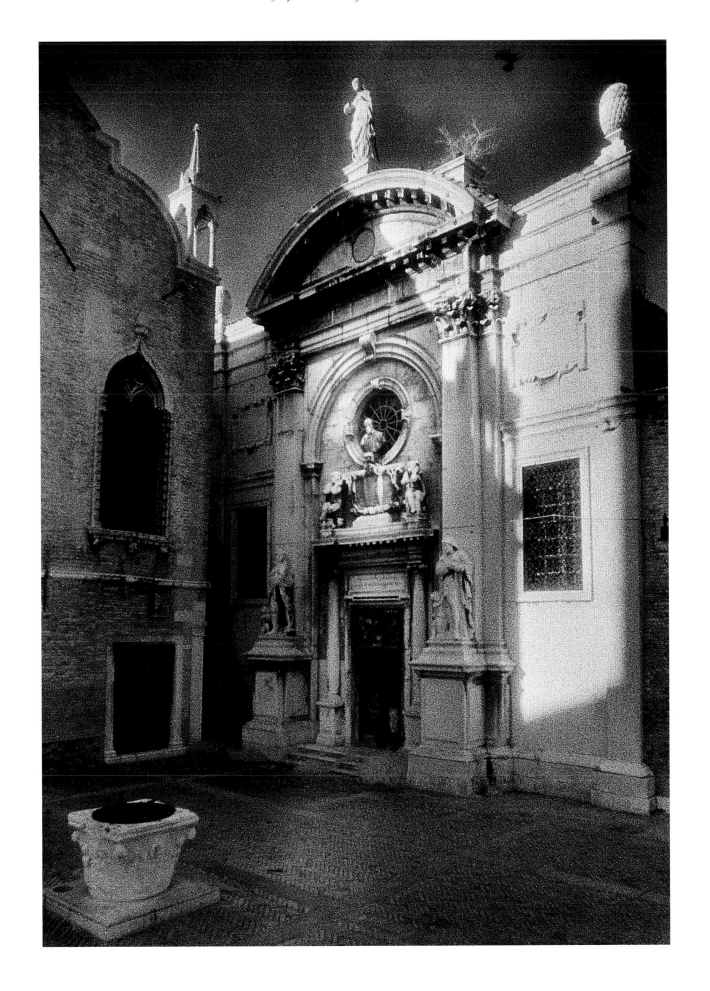

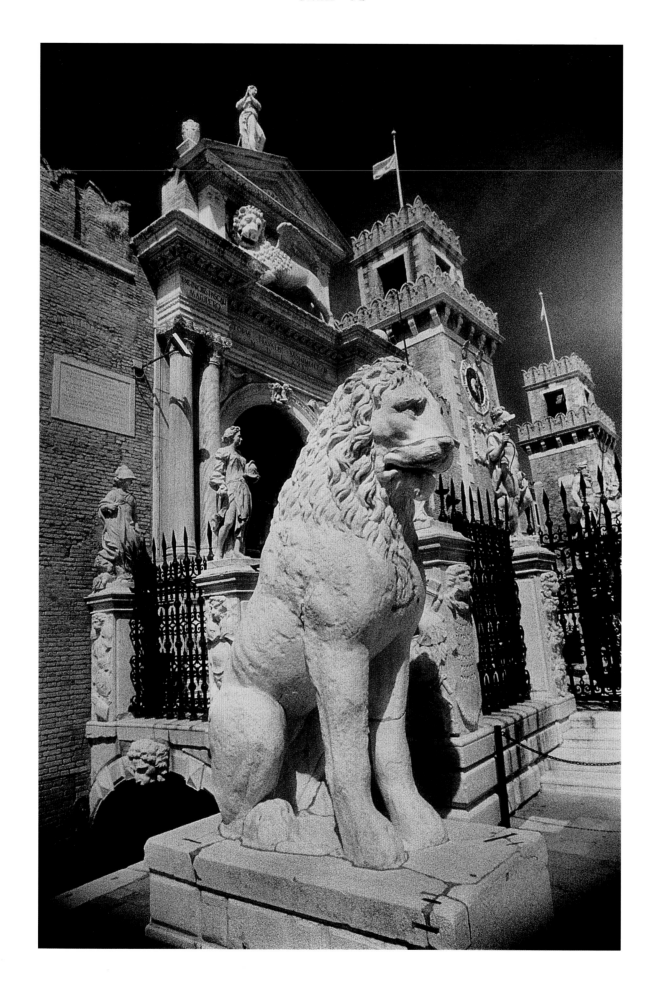

IOANNI.MATHIAE.S.R.I.C. DE SCHULEMBURG.
SUMMO. TERRESTRIUM. COPIARUM. PRAEFECTO.
SENATUS.
POSTRIDIE. IDUS. MARTII.
MDCCXLVII.

I glided off, in one of the dark boats, until we came to an old Arsenal guarded by four marble lions.
To make my Dream more monstrous and unlikely, one of these had words
and sentences upon its body, inscribed there, at an unknown time, and in an unknown language;
so that their purport was a mystery to all men.

CHARLES DICKENS
An Italian Dream, 1844

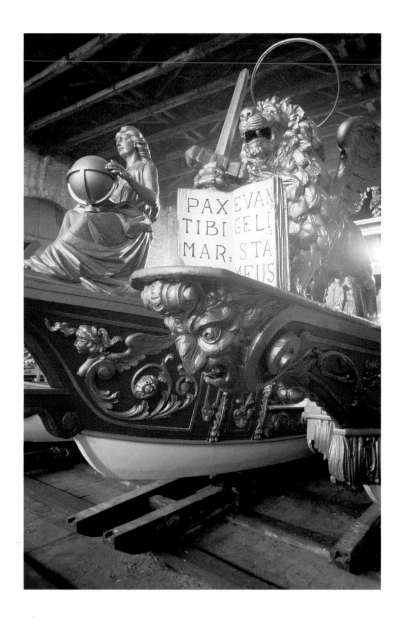

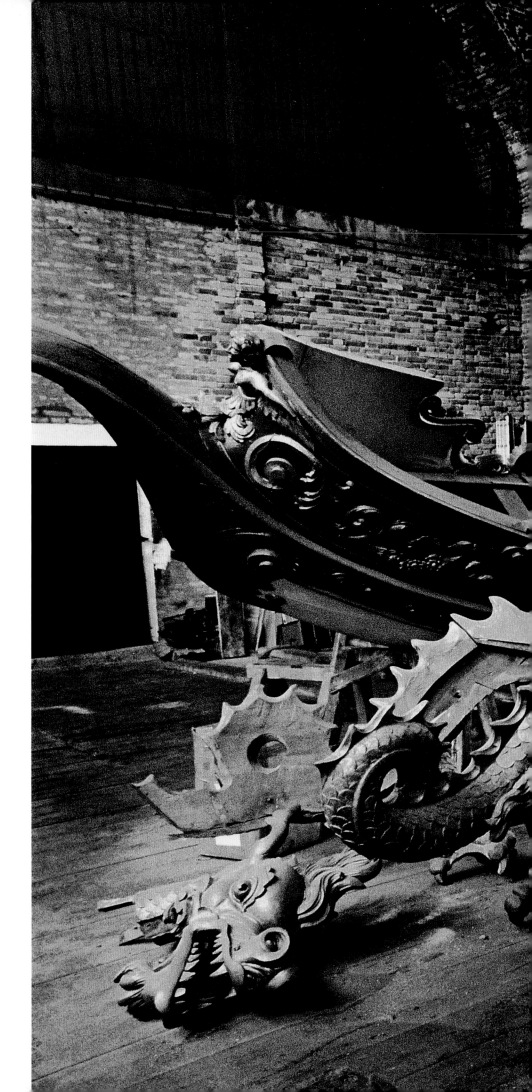

here was little sound of hammers in this place for building ships, and little work in progress; for the greatness of the city was no more, as I have said. Indeed, it seemed a very wreck found drifting on the sea; a strange flag hoisted in its honourable stations, and strangers standing at its helm.

CHARLES DICKENS
An Italian Dream, 1844

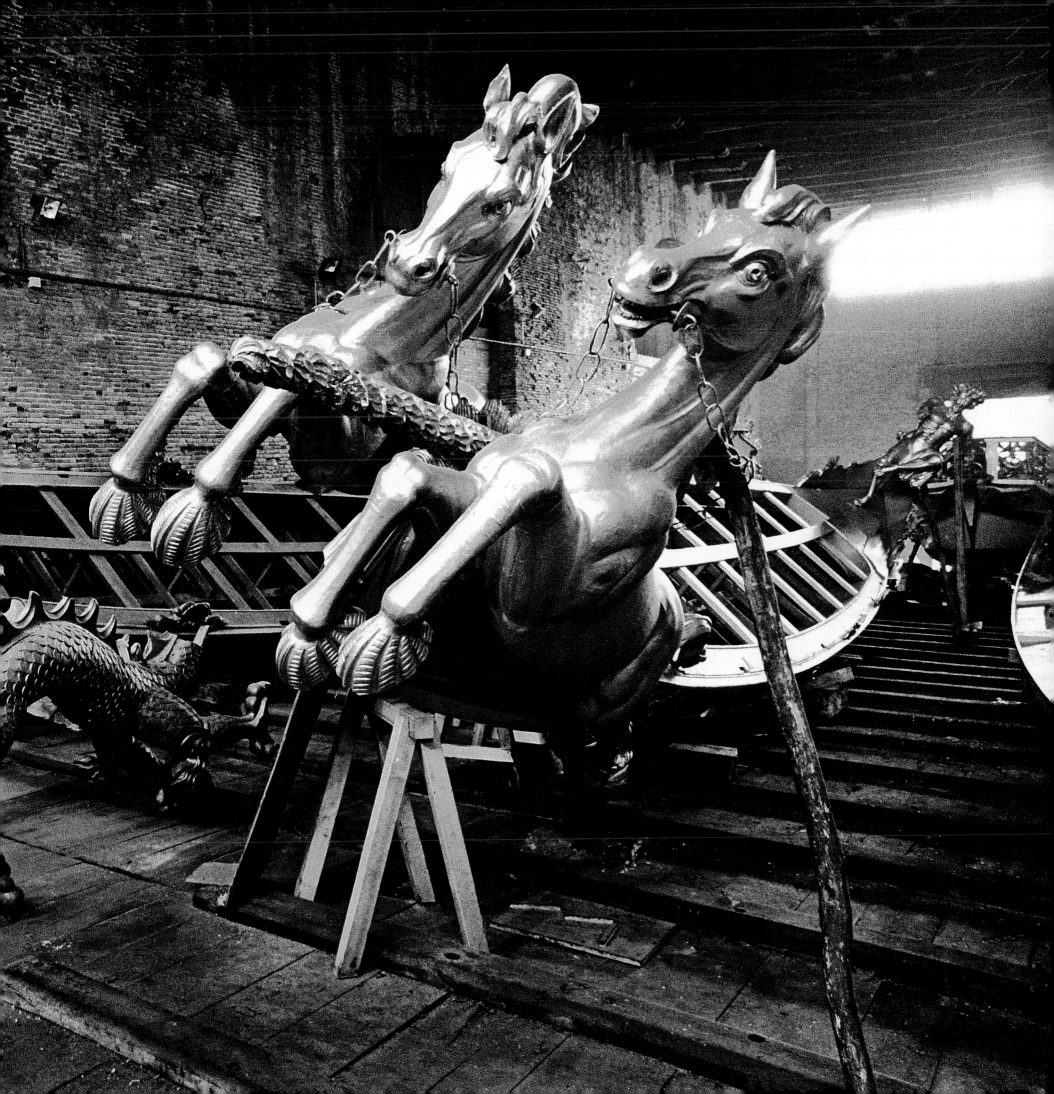

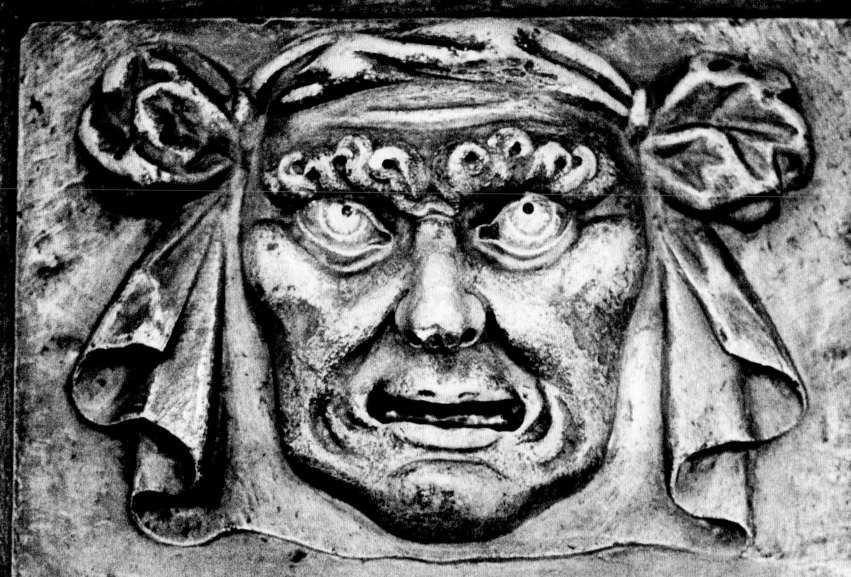

DENONTIE SECRETE
CONTRO CHI OCCVLTERA
GRATIE ET OFFICII,
Ō COLLVDERA PER
NASCONDER LA VERA
RENDITA Ð ESSI

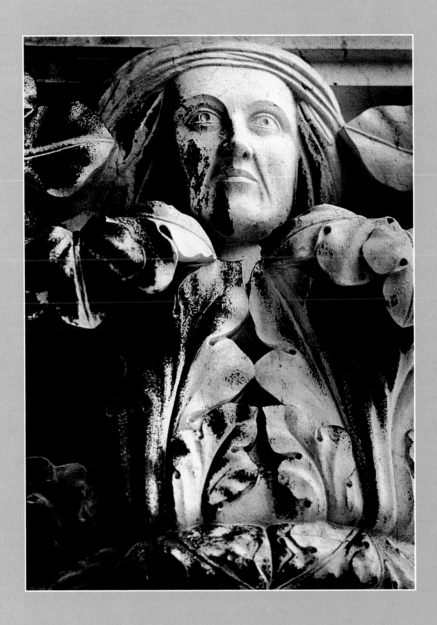

But first I passed two jagged slits in a stone wall; the lions' mouths – now toothless – where,

in the distempered horror of my sleep, I thought denunciations of

innocent men to the old wicked Council, had been dropped through, many a time, when the night was dark.

CHARLES DICKENS
An Italian Dream, 1844

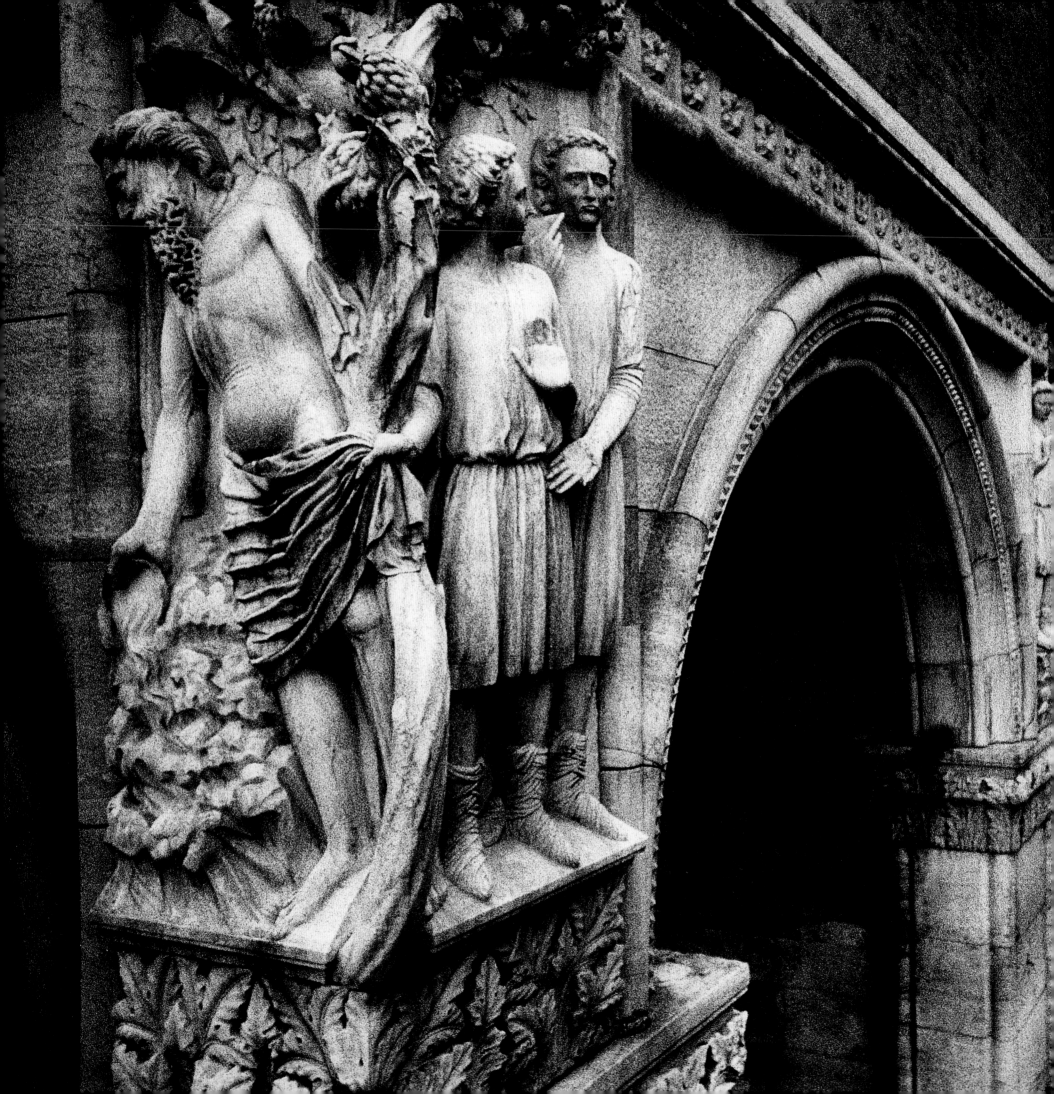

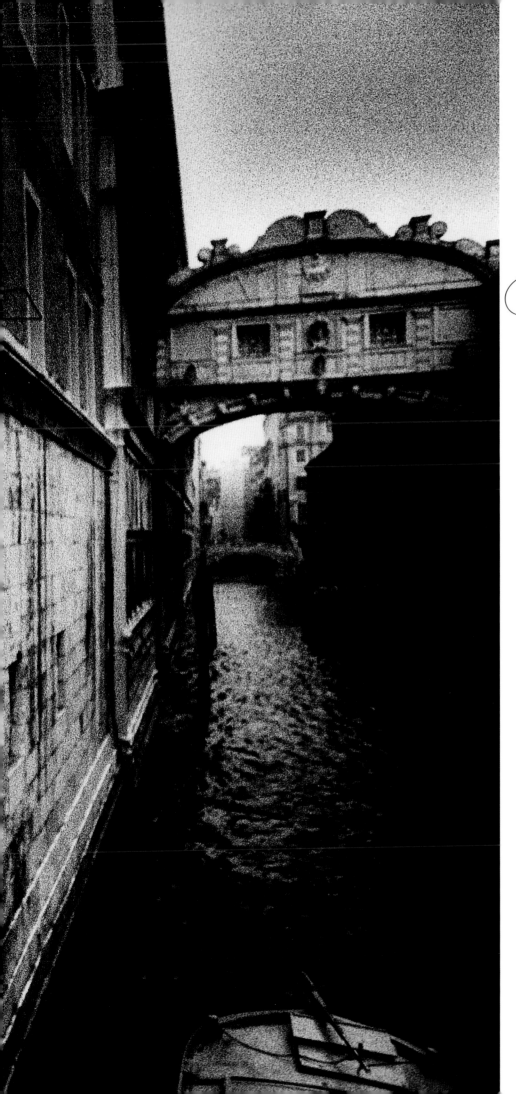

The walls are covered in most places with grim visages sculptured in marble, whose mouths gape for accusations, and swallow every lie that malice and revenge can dictate. I wished for a few ears of the same kind, dispersed about the Doge's residence, to which one might apply one's own, and catch some account of the mysteries within; some little dialogue between the three Inquisitors, or debate in the Council of Ten. This is the tribunal which holds the wealthy nobility in continual awe; before which they appear with trembling and terror; and whose summons they dare not disobey. Sometimes, by way of clemency, it condemns its victims to perpetual imprisonment, in close, stifling cells, between the leads and beams of the palace; or, unwilling to spill the blood of a fellow-citizen, generously sinks them into dungeons, deep under the canals which wash its foundations; so that, above and below, its majesty is contaminated by the abodes of punishment . . .

. . . I left the courts, and stepping into my bark, was rowed down a canal over which the lofty vaults of the palace cast a tremendous shade. Beneath these fatal waters the dungeons I have also been speaking of are situated. There the wretches lie marking the sound of the oars, and counting the free passage of every gondola. Above, a marble bridge, of bold majestic architecture, joins the highest part of the prisons to the secret galleries of the palace: from whence criminals are conducted over the arch to a cruel and mysterious death . . . Horrors and dismal prospects haunted my fancy upon my return. I could not dine in peace, so strongly was my imagination affected; but snatching my pencil, I drew chasms, and subterranean hollows, the domain of fear and torture, with chains, racks, wheels, and dreadful engines in the style of Piranesi.

WILLIAM BECKFORD
Dreams, Waking Thoughts and Incidents, 1783

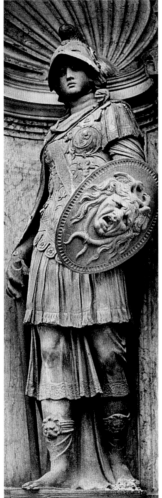

In course of time the captain of the men-at-arms came to tell me that he was under orders to take me *under the Leads*. Without a word I followed him. We went by gondola, and after a thousand turnings among the small canals we got into the Grand Canal, and landed at the prison quay. After climbing several flights of stairs we crossed a closed bridge which forms the communication between the prisons and the Doge's palace, crossing the canal called Rio di Palazzo. On the other side of this bridge there is a gallery which we traversed. We then crossed one room, and entered another, where sat an individual in the dress of a noble, who, after looking fixedly at me, said, 'E quello, mettetelo in deposito.'

This man was the secretary of the Inquisitors, the prudent Dominic Cavalli, who was apparently ashamed to speak Venetian in my presence as he pronounced my doom in the Tuscan language.

Messer-Grande then made me over to the warden of The Leads, who stood by with an enormous bunch of keys, and accompanied by two guards, made me climb two short flights of stairs, at the top of which followed a passage and then another gallery, at the end of which he opened a door, and I found myself in a dirty garret, thirty-six feet long by twelve broad, badly lighted by a window high up in the roof. I thought this garret was my prison, but I was mistaken; for, taking an enormous key, the gaoler opened a thick door lined with iron, three and a half feet high, with a round hole in the middle, eight inches in diameter, just as I was looking intently at an iron machine. This machine was like a horse shoe, an inch thick and about five inches across from one end to the other. I was thinking what could be the use to which this horrible instrument was put, when the gaoler said, with a smile, –

'I see, sir, that you wish to know what that is for, and as it happens I can satisfy your curiosity. When their excellencies give orders that anyone is to be strangled, he is made to sit down on a stool, the back turned to this collar, and his head is so placed that the collar goes round one half of the neck. A silk band, which goes round the other half, passes through this hole, and the two ends are connected with the axle of a wheel which is turned by someone until the prisoner gives up the ghost, for the confessor, God be thanked!, never leaves him till he is dead.'

GIOVANNI GIACOMO CASANOVA
Adventurer, profligate, alchemist and Knight of the Papal Order of the Golden Spur.
The most celebrated of all the prisoners of the cells of the Doge's Palace and one of the very few who succeeded in escaping.
from *The Memoirs of Jacques Casanova de Seingalt* (1725–1798), translated by Arthur Machen.

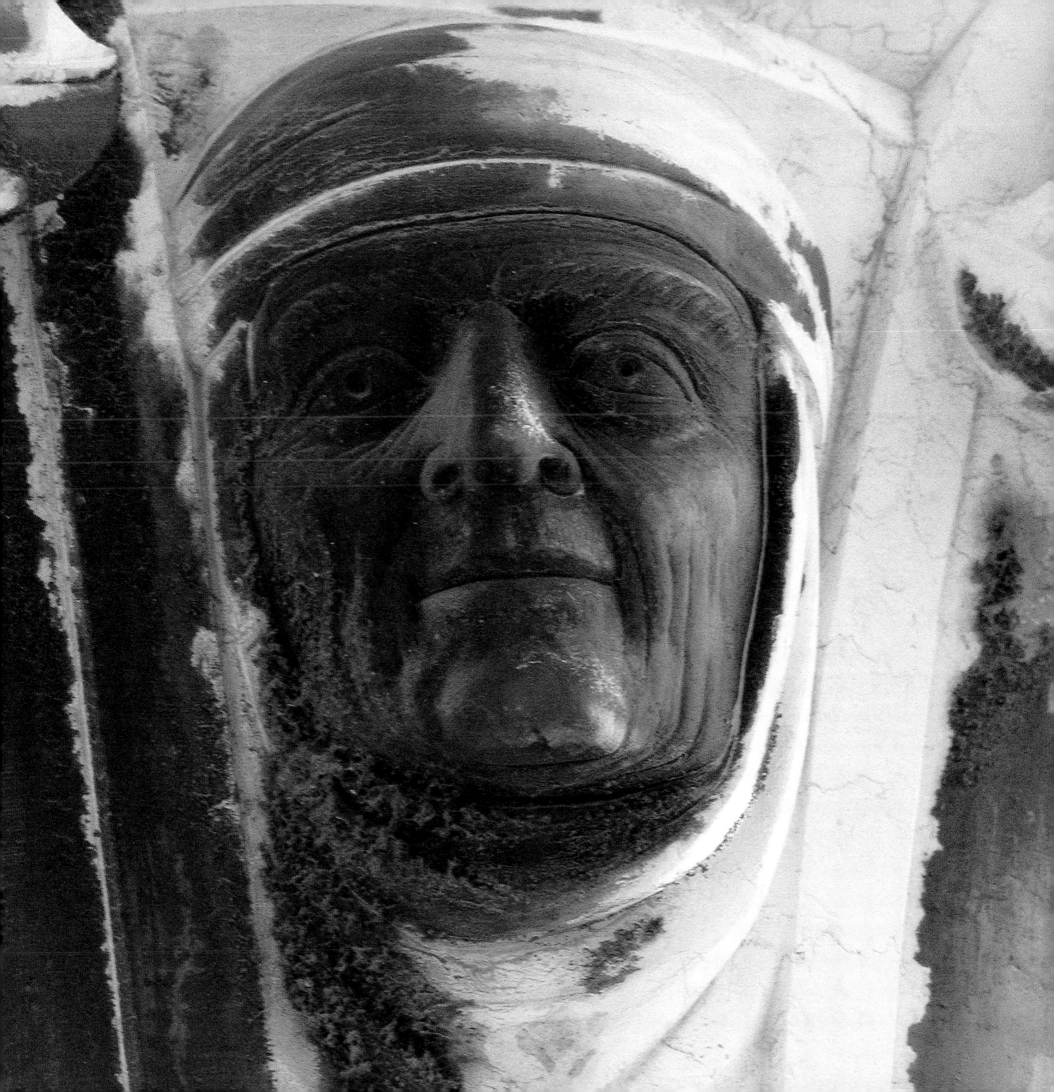

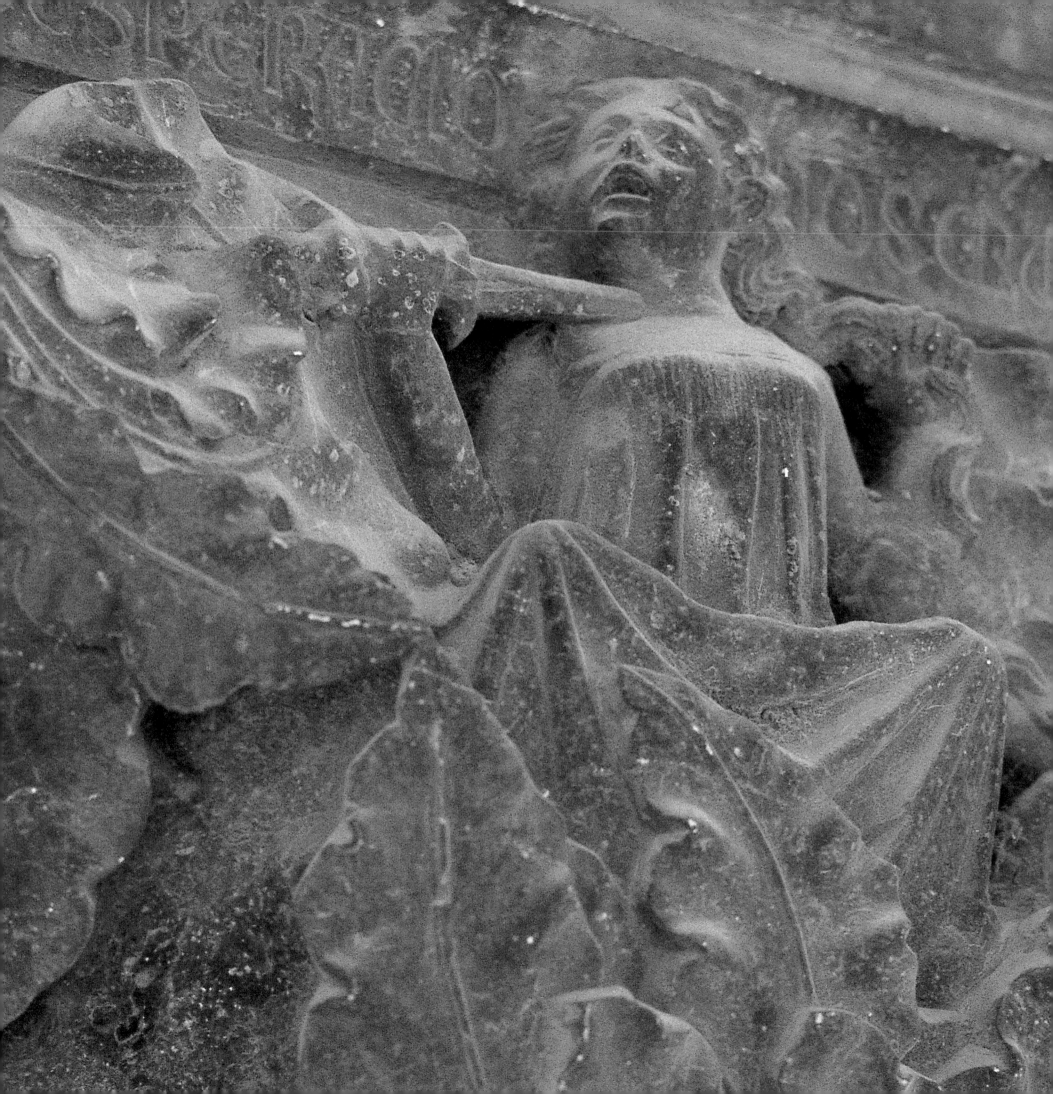

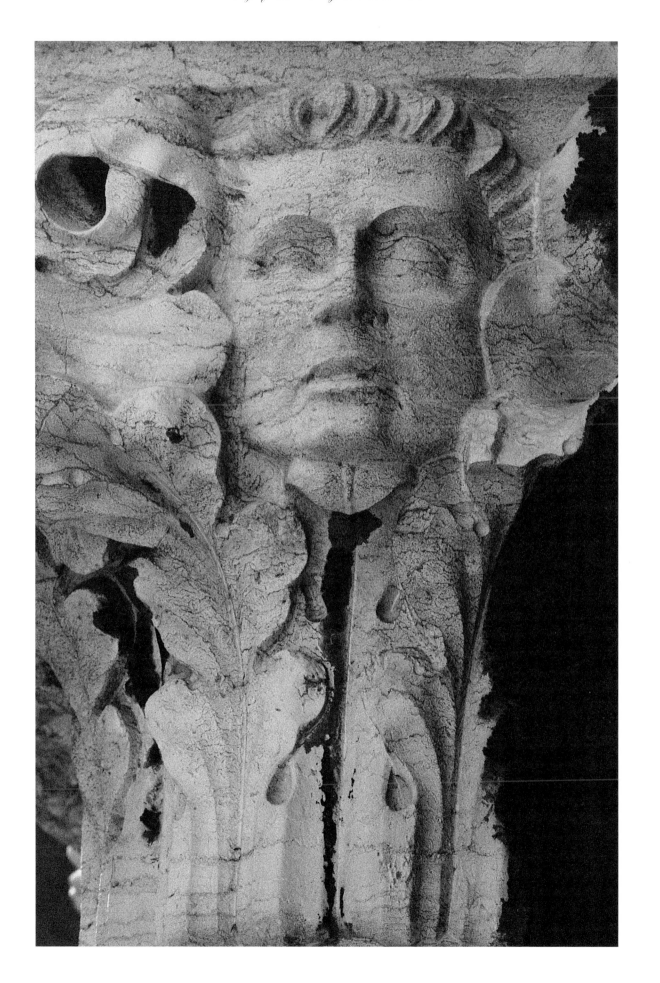

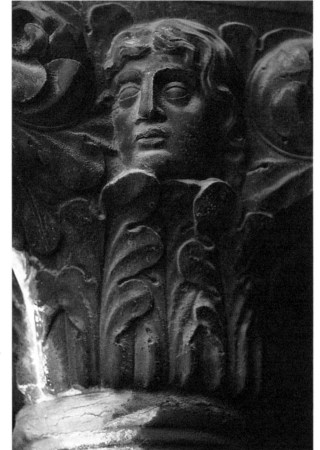

The clock striking midnight awoke me. How sad is the awaking when it makes one regret one's empty dreams. I could scarcely believe that I had spent three painless hours. As I lay on my left side, I stretched out my right hand to get my handkerchief, which I remembered putting on that side. I felt about for it, when — heavens! what was my surprise to feel another hand as cold as ice. The fright sent an electric shock through me, and my hair began to stand on end.

Never had I been so alarmed, nor should I have previously thought myself capable of experiencing such terror. I passed three or four minutes in a kind of swoon, not only motionless but incapable of thinking. As I got back my senses by degrees, I tried to make myself believe that the hand I fancied I had touched was a mere creature of my disordered imagination; and with this idea I stretched out my hand again, and again with the same result. Benumbed with fright, I uttered a piercing cry, and, dropping the hand I held, I drew back my arm, trembling all over.

Soon as I got a little calmer and more capable of reasoning, I concluded that a corpse had been placed beside me whilst I slept, for I was certain it was not there when I lay down.

'This,' said I, 'is the body of some strangled wretch, and they would thus warn me of the fate which is in store for me.'

The thought maddened me; and my fear gave way to rage, for the third time I stretched my arm towards the icy hand, seizing it to make certain of the fact in all its atrocity, and wishing to get up, I rose upon my left elbow, and found that I had got hold of my other hand. Deadened by the weight of my body and the hardness of the boards, it had lost warmth, motion, and all sensation . . .

GIOVANNI GIACOMO CASANOVA
from *The Memoirs of Jacques Casanova de Seingalt* (1725–1798), translated by Arthur Machen.

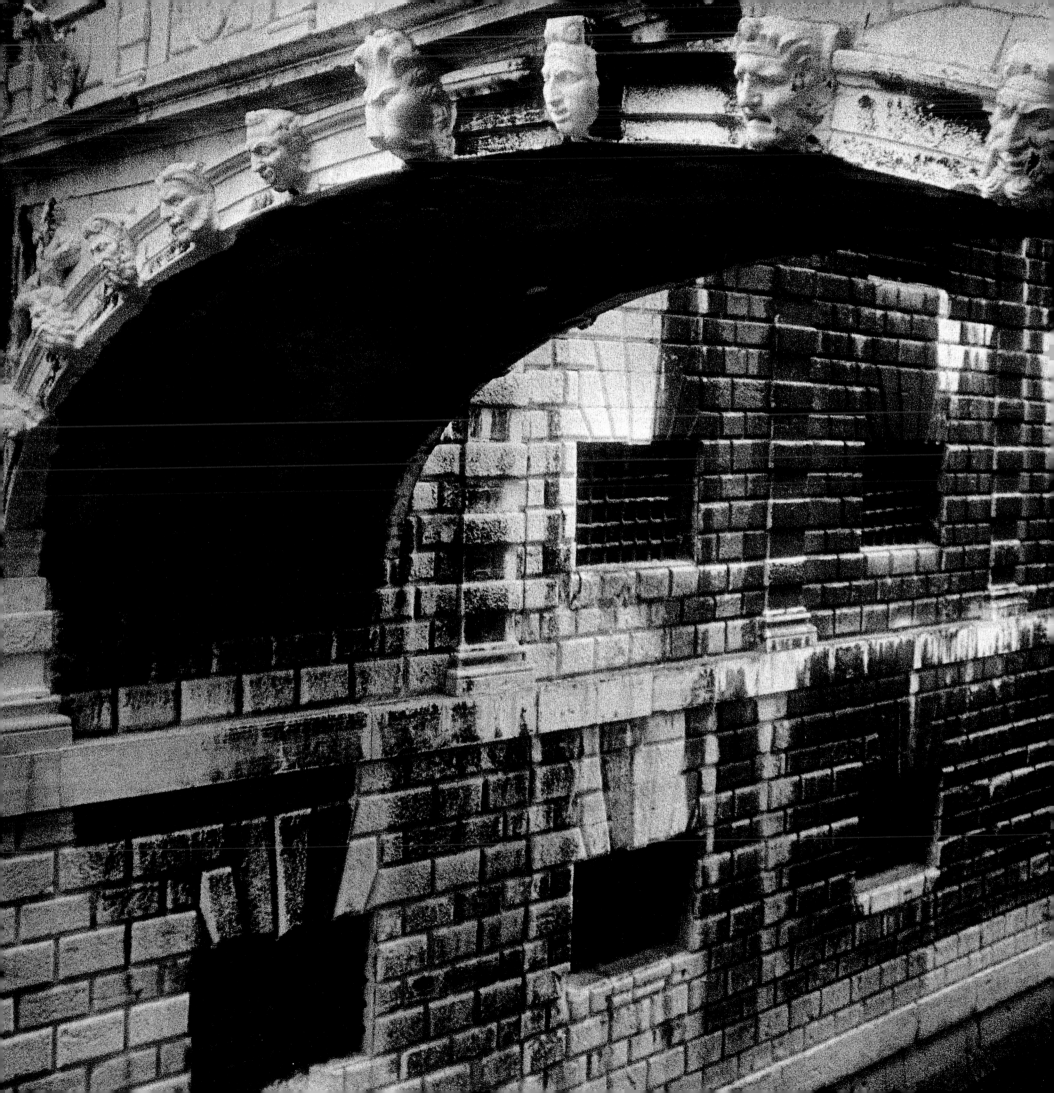

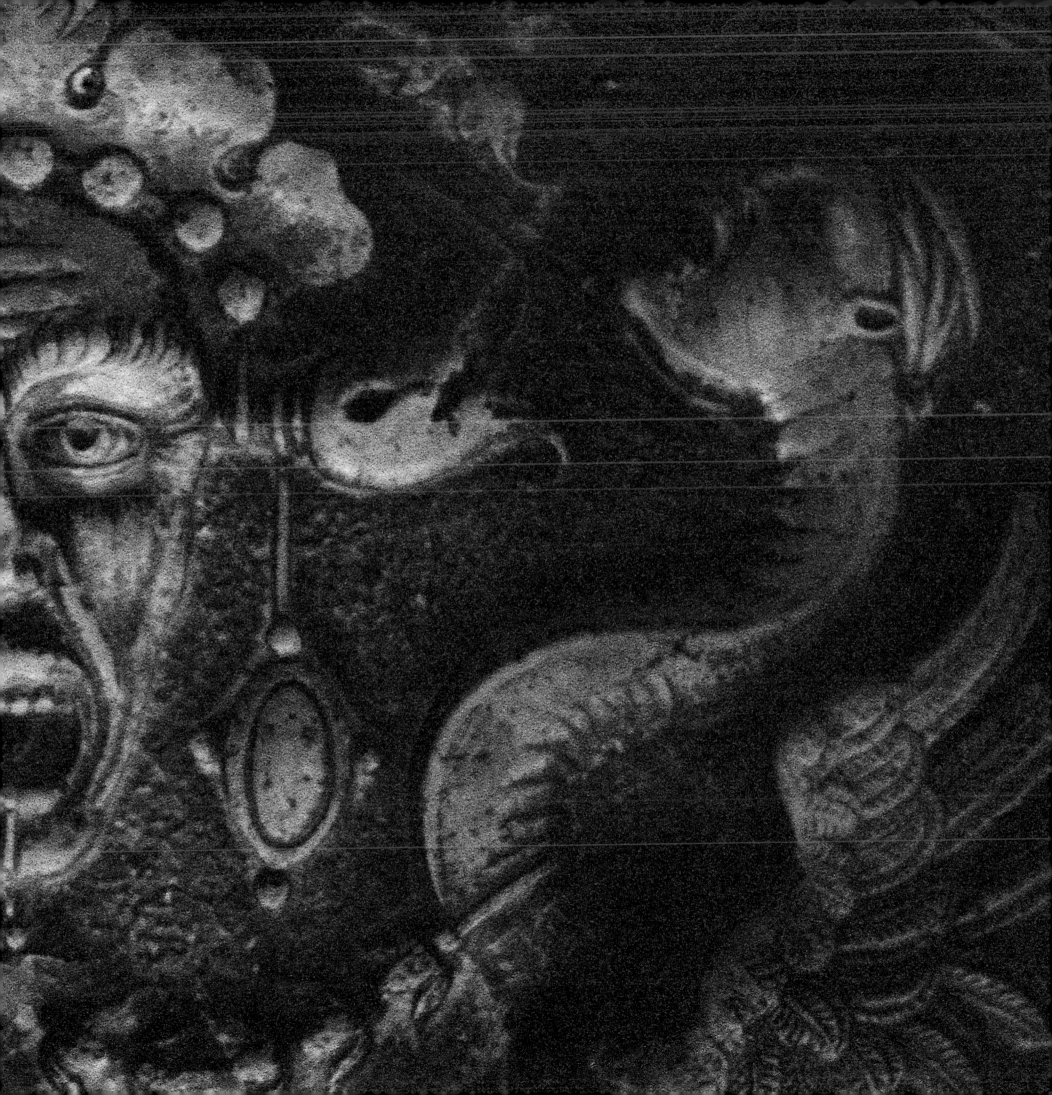

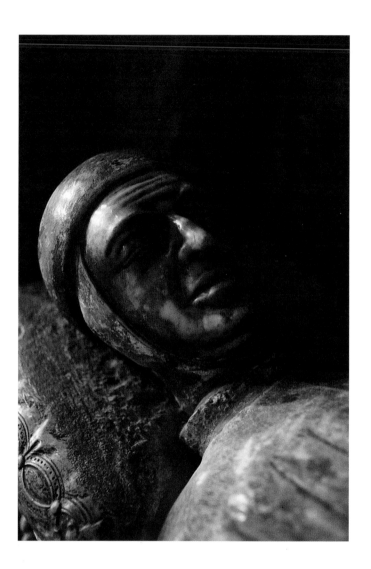

One cell, I saw, in which no man remained for more than four-and-twenty hours; being marked for dead before he entered it. Hard by, another, and a dismal one, whereto, at midnight, the confessor came – a monk brown-robed, and hooded – ghastly in the day, and free bright air, but in the midnight of that murky prison, Hope's extinguisher, and Murder's herald. I had put my foot upon the spot, where, at the same dread hour, the shriven prisoner was strangled; and struck my hand upon the guilty door – low-browed and stealthy – through which the lumpish sack was carried out into a boat, and rowed away, and drowned where it was death to cast a net.

CHARLES DICKENS
An Italian Dream, 1844

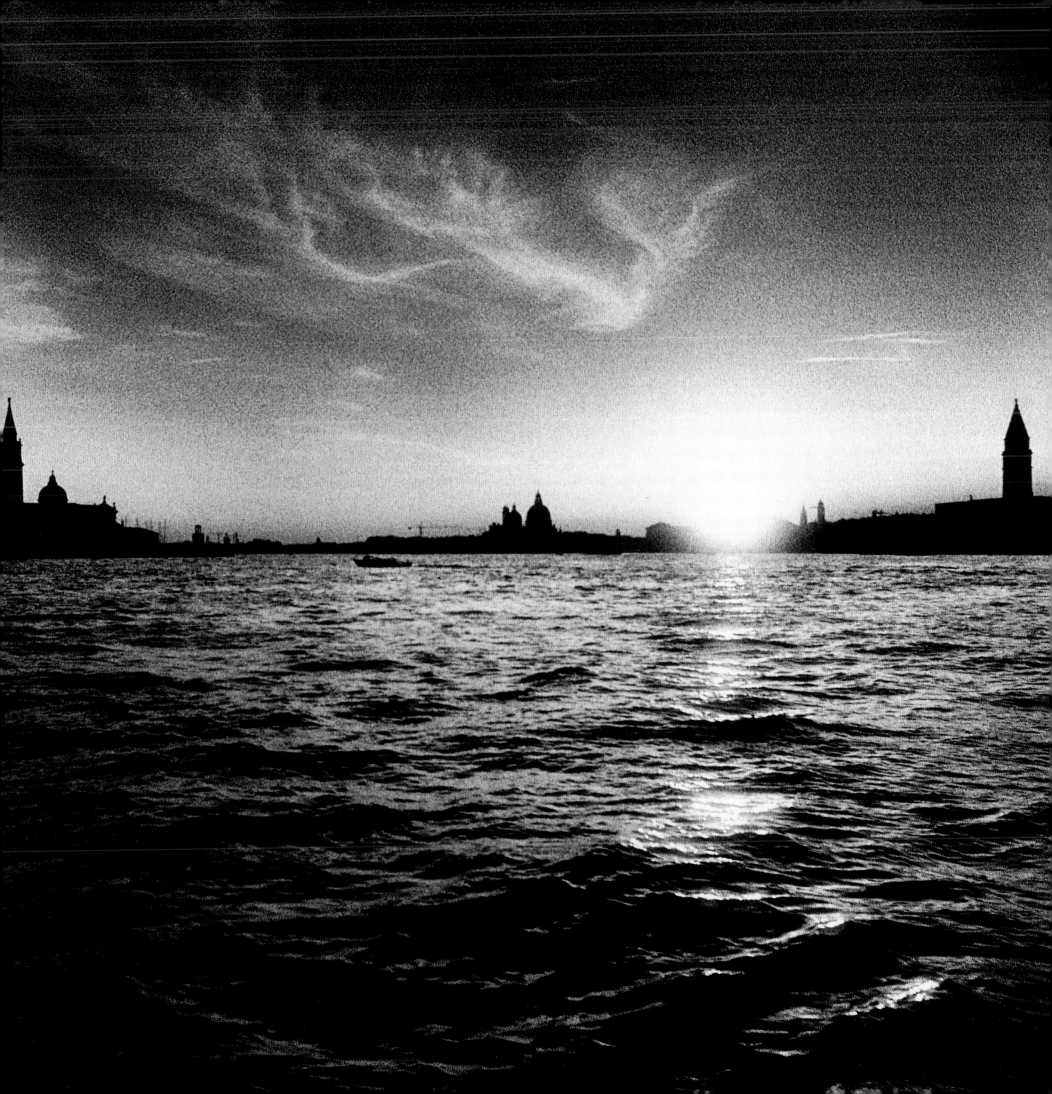

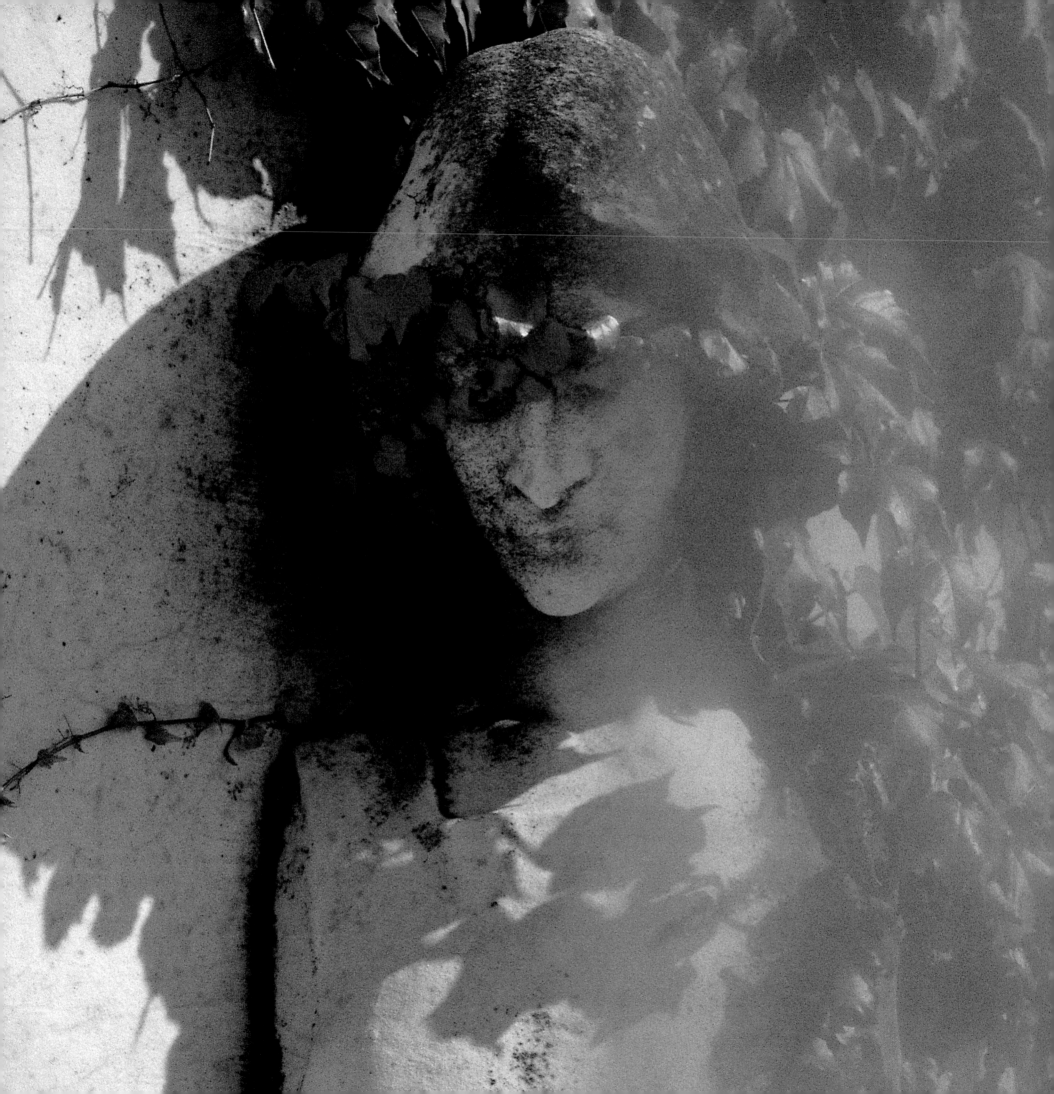

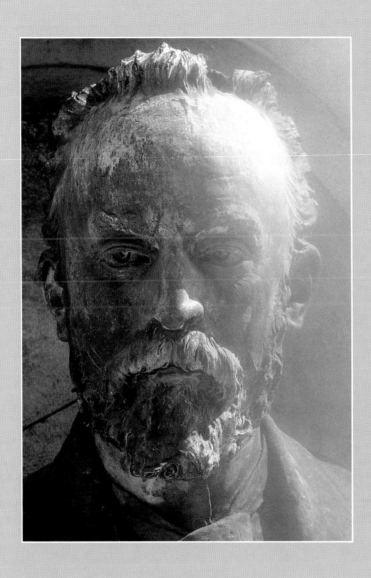

The boundaries which divide life from death are at best shadowy and vague.
Who shall say where the one ends, and where the other begins?

EDGAR ALLAN POE
'The Premature Burial', from *Tales of Mystery and Imagination*, 1908

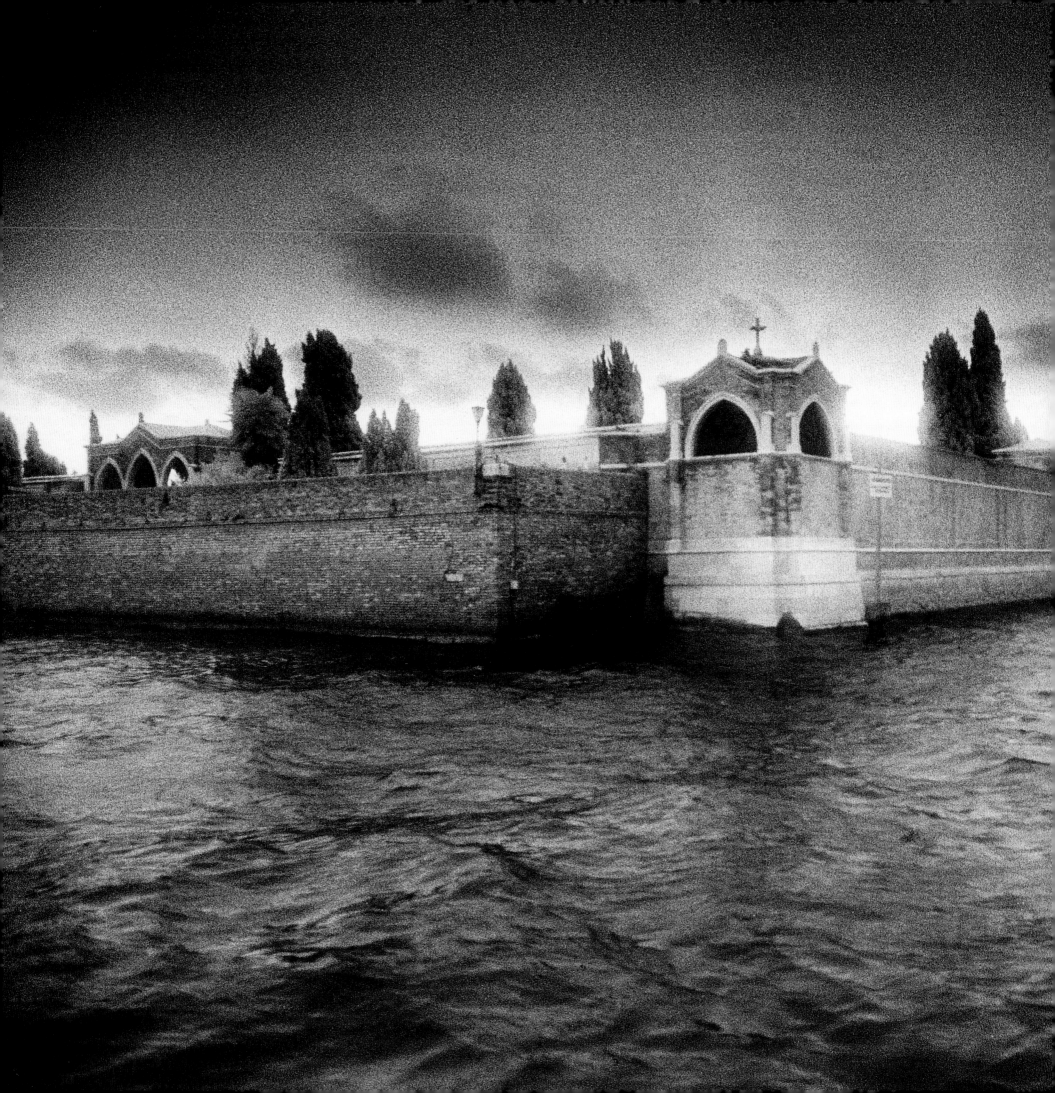

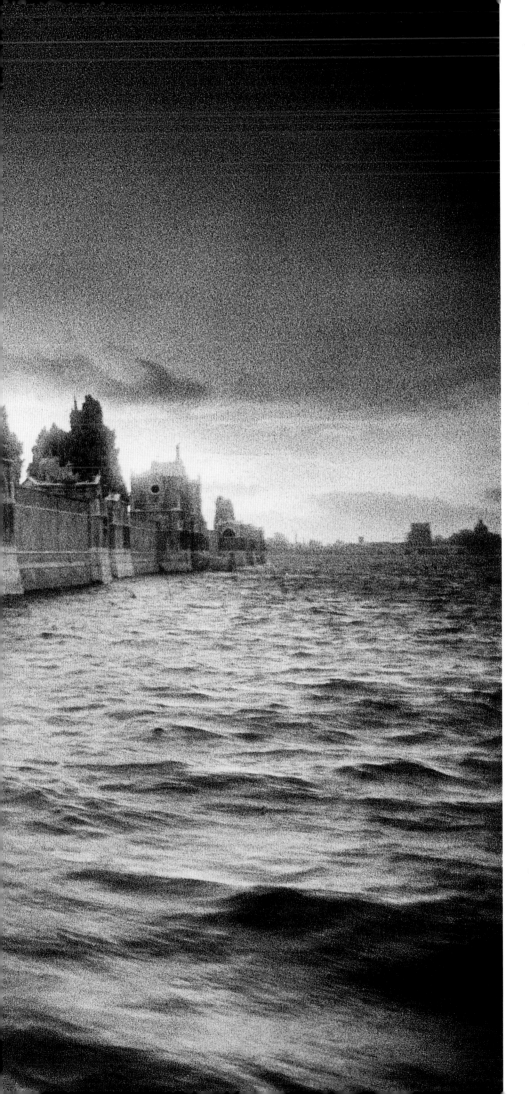

We had floated on, five miles or so, over the dark water, when I heard it rippling in my dream, against some obstruction near at hand. Looking out attentively, I saw, through the gloom, a something black and massive – like a shore, but lying close and flat upon the water, like a raft – which we were gliding past. The chief of the two rowers said it was a burial-place.

CHARLES DICKENS
An Italian Dream, 1844

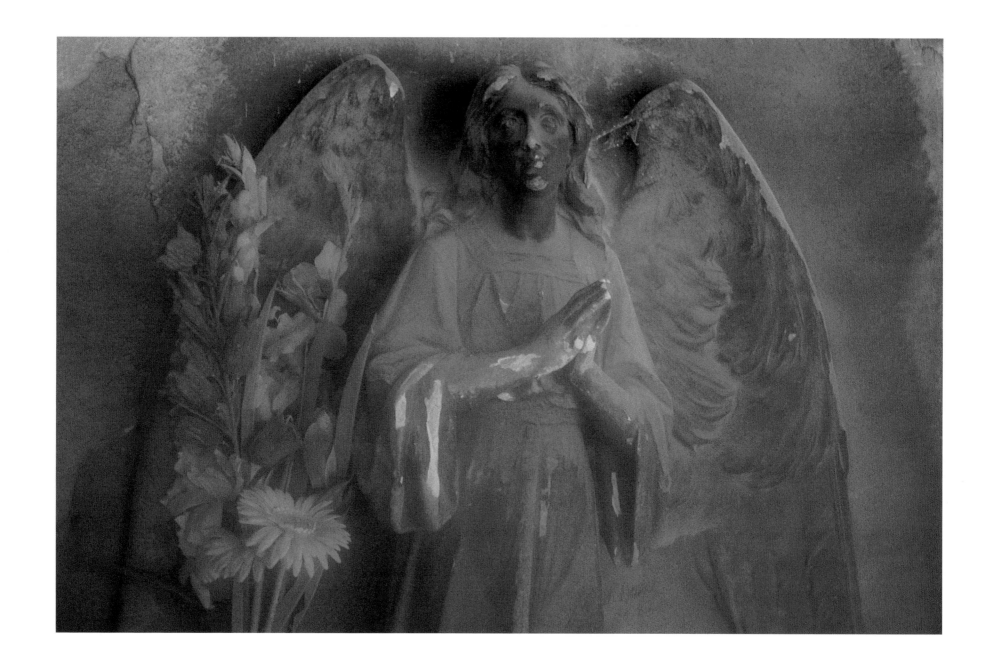

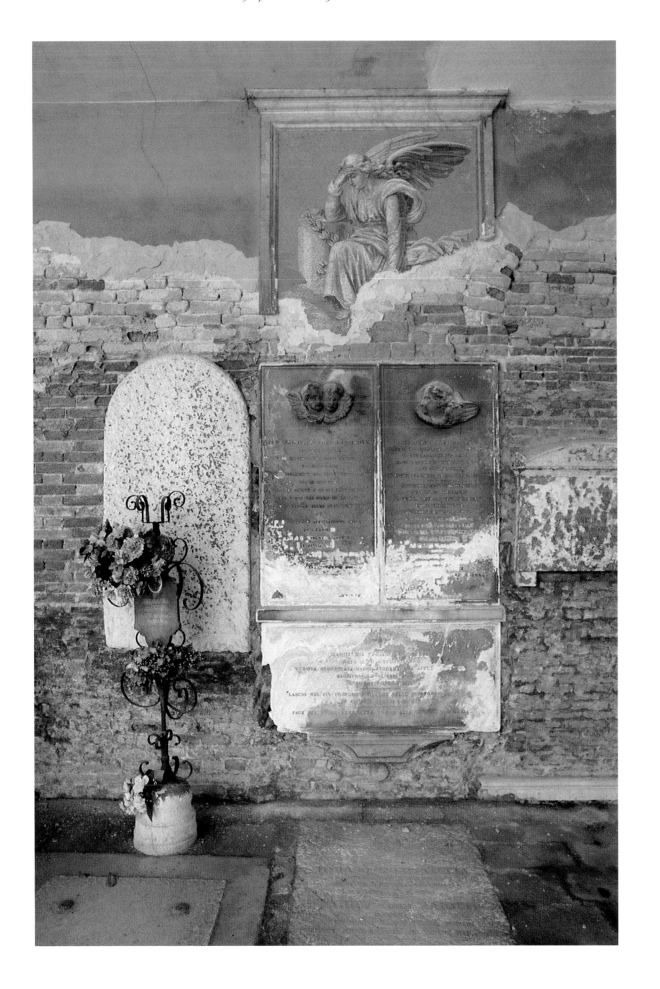

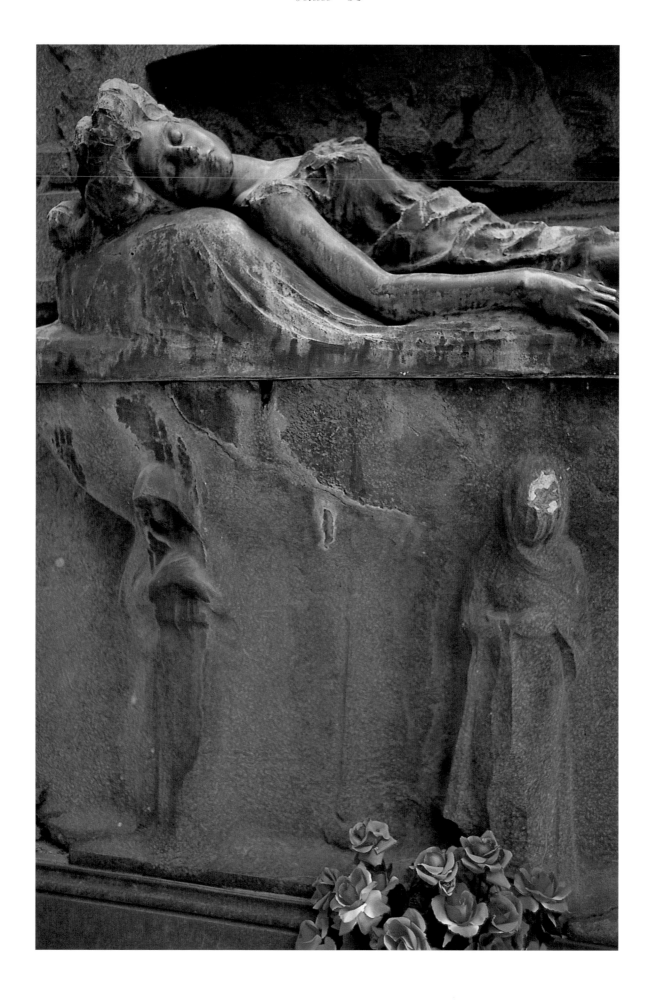

The sylphs and ondines
And the seakings and queens
Once, on the waves built a wonderful a city,
As lovely as seems
To some bard, in his dreams,
The soul of his sweetest love-ditty.
Long ago! long ago! ah, that was long ago! –
Thick, as on chalices
Kings keep for treasure,
Jewel-born lustres,
Temples and palaces,
Places of pleasure,
Glitter'd in clustres;
Night broke out shining
With splendour and festival
O'er the meandering murmurous streets,
Seawaves went pining
With love thro' the musical
Multiform bridges and marble retreats
Of this city of wonder, where dwelt the ondines
Long ago, and the sylphs, and the seakings and queens.
Ah, that was long ago! –
But the sylphs and ondines,
And the seakings and queens
Are fled under the waves.
And I glide, unespied,
Down the glimmering tide,
('Mid forms silently passing, as silent as any!)
Here in the waves
Of this city of graves
To bury my heart, – one grave more to the many! –

EDWARD ROBERT BULWER LYTTON,
EARL OF LYTTON
'Venice', from *The Poems*, 1831

*S*lowly we came out north of Burano into the open lagoon; and rowed eastward to meet the night, as far as the point marked by five *pali*, where the wide canal curves to the south. Slowly we went. There was something so holy – so majestically holy – in that evening silence, that I would not have it broken even by the quiet plash of oars. I was lord of time and place. No engagements cried to be kept. I could go when and where I pleased, fast or slow, far or near. And I chose the near and the slow. I did more. So unspeakably gorgeous was the peace on the lagoon just then, that it inspired me with a lust for doing nothing at all but sitting and absorbing impressions motionlessly. That way come thoughts, new, generally noble.

A.J.A. SYMONS
The Quest for Corvo, 1966

Frederick Rolfe, the self-styled Baron Corvo, had been rejected for the Catholic priesthood, but never renounced his vocation. He later became a writer, but his homosexuality and obsessive eccentricities set him apart. He spent the last five years of his life in Venice, pursuing a lifestyle that swung between starvation and extreme extravagance. He is buried on San Michele, known as 'The Island of the Dead'.

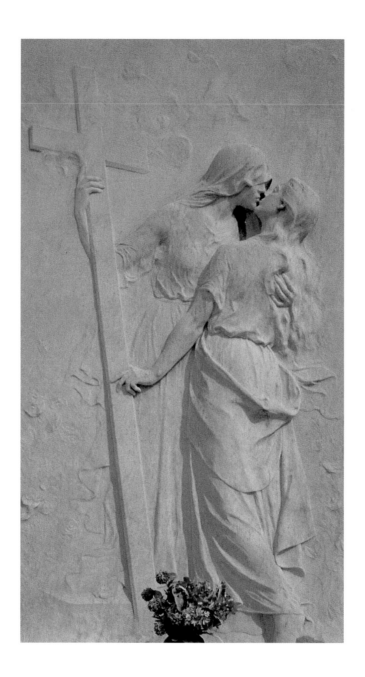

In the ages of rude primeval culture, man believed that in dreams he was coming to know a *second real world*; here is the source of all metaphysics. Without dreams one would have found no cause to split the world. The division into soul and body is also connected with the oldest conception of the dream, and similarly the postulation of a life of the soul, thus the origin of all belief in spirits, and probably of belief in gods too. 'The dead live on, *because* they appear to the living in dreams': thus man used to reason, throughout thousands of years.

FRIEDRICH NIETZSCHE
Human, All Too Human, 1878

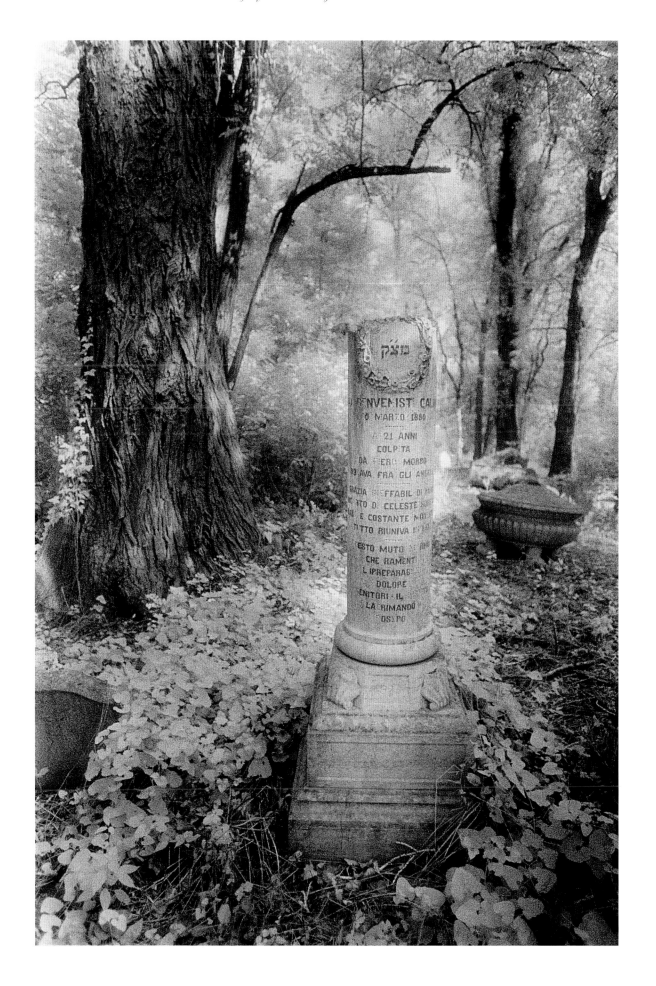

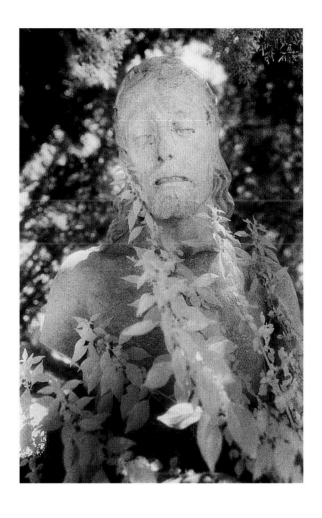

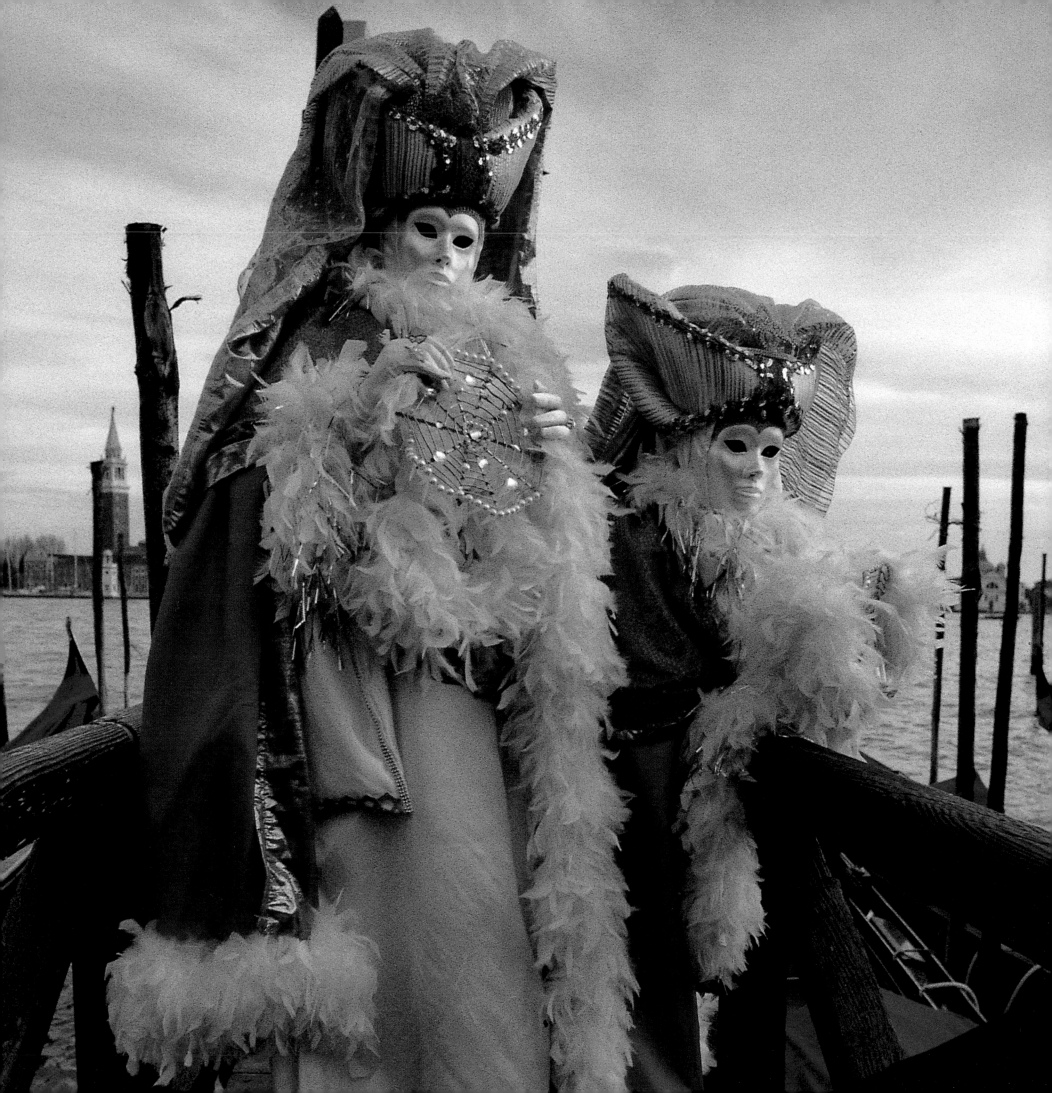

Thenceforward, year after year, the nation drank with deeper thirst from the fountains of forbidden pleasure, and dug for springs, hitherto-unknown, in the dark places of the earth. In the ingenuity of indulgence, in the varieties of vanity, Venice surpassed the cities of Christendom, as of old she had surpassed them in fortitude and devotion; and as once the powers of Europe stood before her judgement seat, to receive the decisions of her justice, so now the youth of Europe assembled in the halls of her luxury, to learn from her arts of delight.

It is as needless as it is painful to trace the steps of her final ruin. That ancient curse was upon her, the curse of the Cities of the Plain, 'Pride, fulness of bread, and abundance of idleness.' By the inner burning of her own passions, as fatal the fiery rain of Gomorrah, she was consumed from her place among the nations; and her ashes are choking the channels of the dead, salt sea.

JOHN RUSKIN
The Stones of Venice, 1853

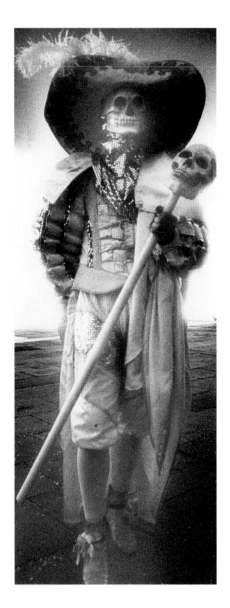

To dream has been the business of my life, I have therefore framed for myself, as you see, a bower of dreams. In the heart of Venice could I have erected a better? You behold around you, it is true, a medley of architectural embellishments. The chastity of Iona is offended by antediluvian devices, and the sphynxes of Egypt are outstretched upon carpets of gold. Yet the effect is incongruous to the timid alone. Proprieties of place, and especially of time, are the bugbears which terrify mankind from the contemplation of the magnificent. Once I was a decorist; but that sublimation of folly has palled upon my soul. All this is now the fitter for my purpose. Like these arabesque censers, my spirit is writhing in fire, and the delirium of this scene is fashioning me for the wilder visions of that land of real dreams whither I am now rapidly departing.

EDGAR ALLAN POE
'The Assignation', from *Tales of Mystery and Imagination*, 1908

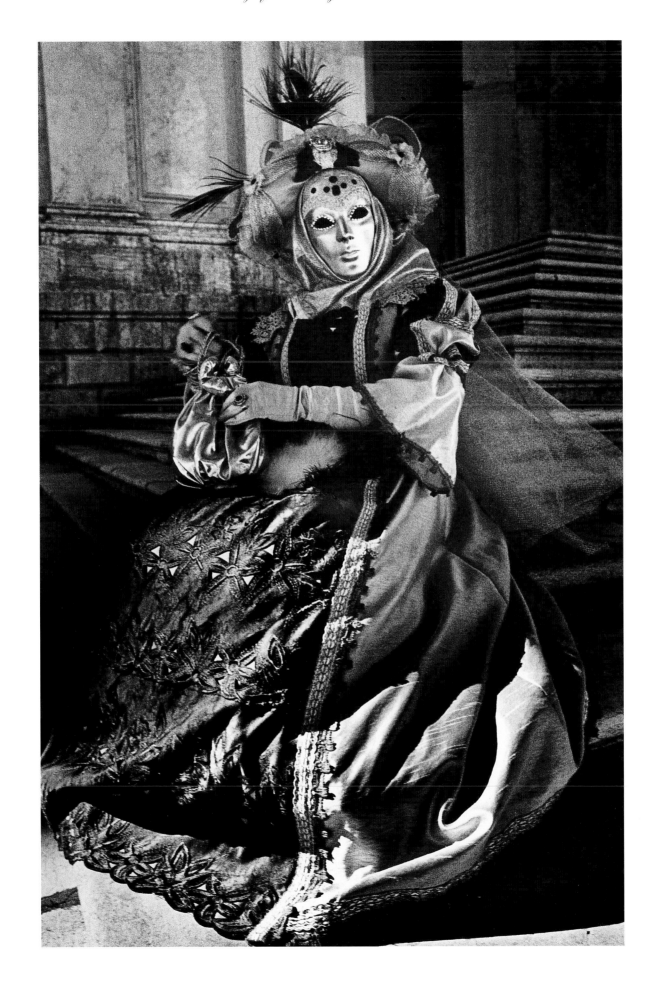

A head, – huge, inhuman, and monstrous, – leering in bestial degradation, too foul
to be either pictured or described, or to be beheld for more than an instant: yet let it be endured for that instant;
for in that head is embodied the type of evil spirit to which Venice was abandoned
in the fourth period of her decline . . .

JOHN RUSKIN
The Stones of Venice, 1853

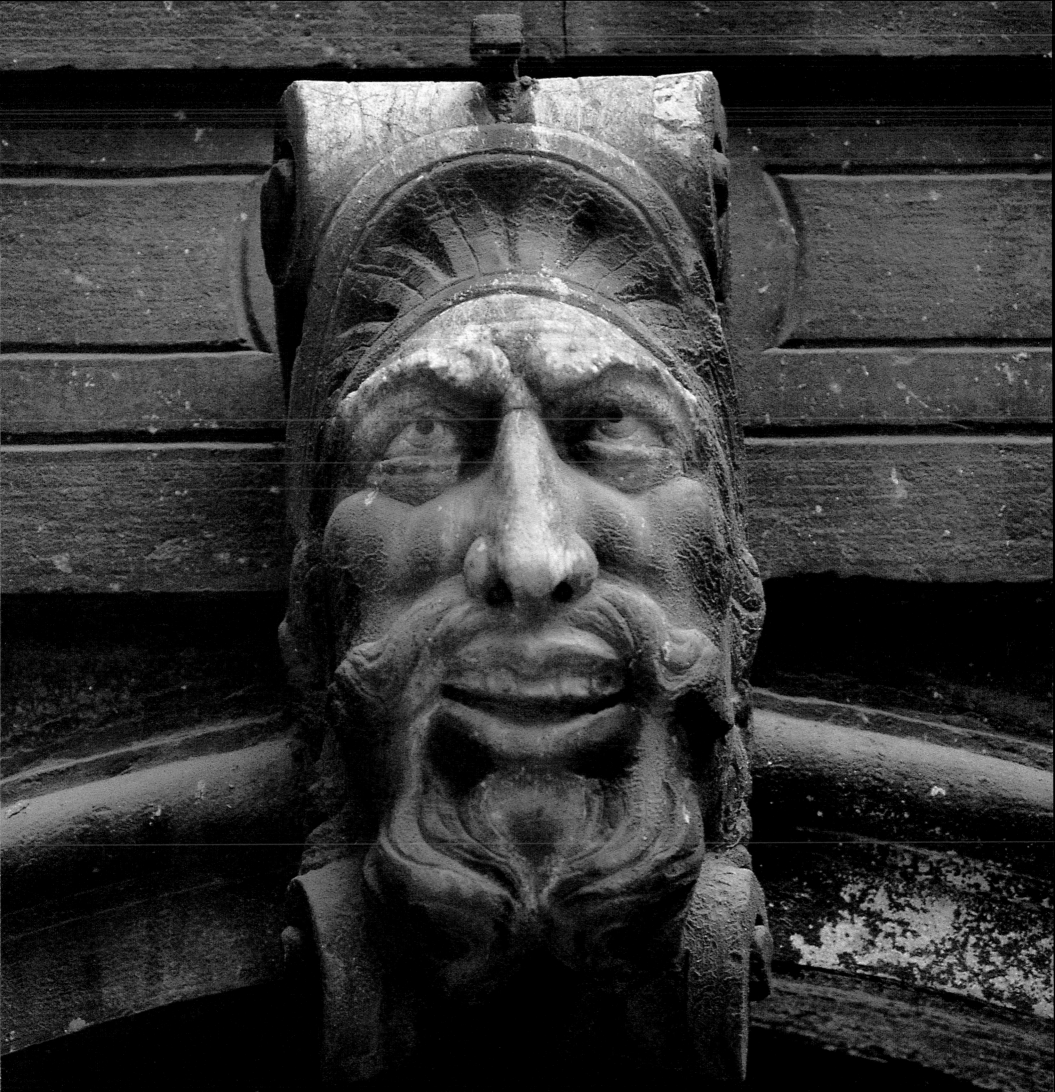

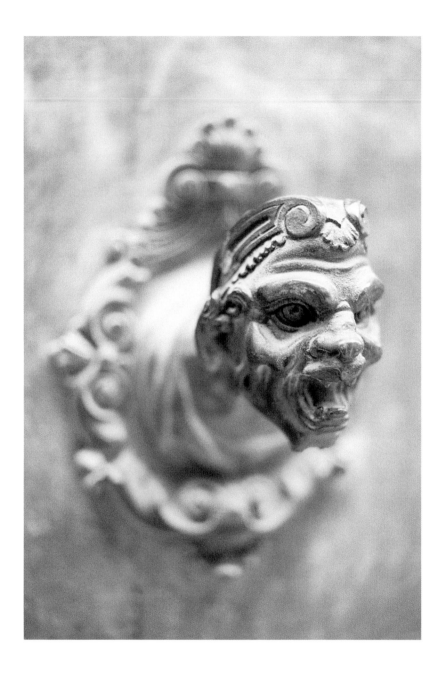

Oppression, chilliness, terror, stole out from these sanguinolent walls; a sickly odour of saltpeter and well water, a mouldy smell reminiscent of prisons, cloisters, and cellars, seized me as I entered it. At the blind windows there was no gleam of light, no appearance of life. The low doors, studded with rusty nails, their iron knockers worn by time, seemed incapable of ever opening.

THÉOPHILE GAUTIER

'Voyage en Italie', from *The Complete Works*, Vol. IV, 1901

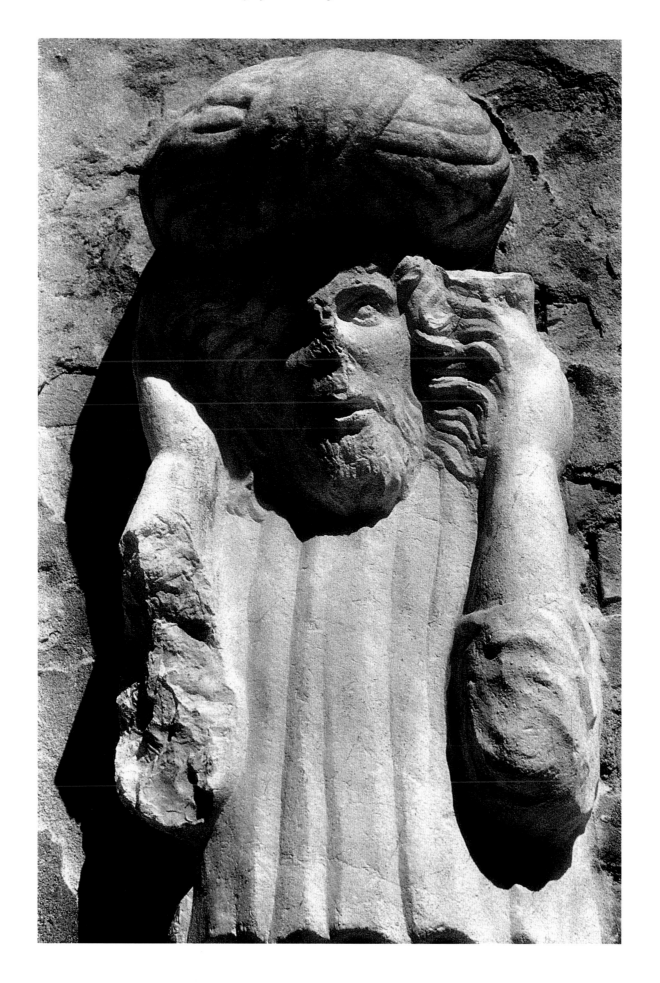

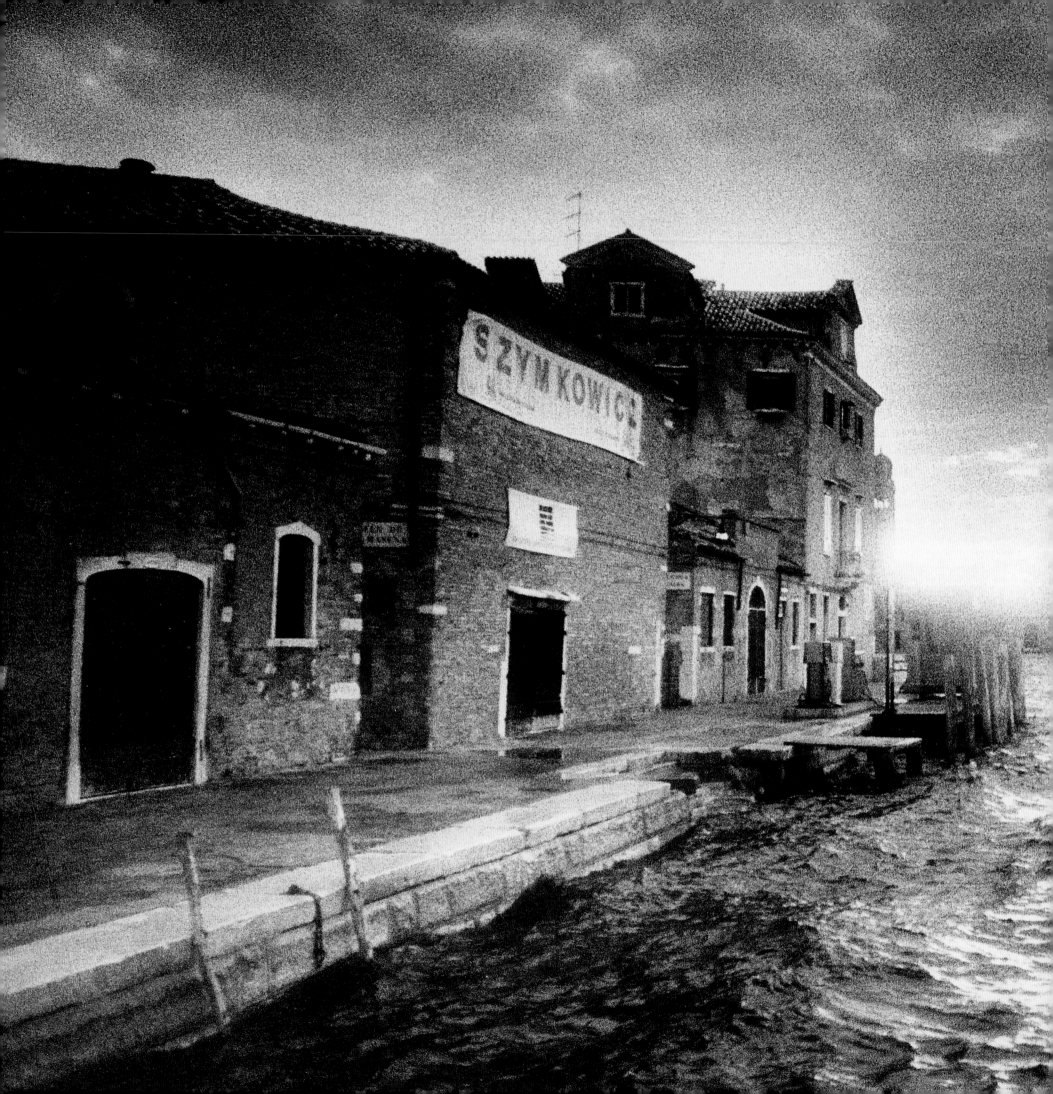

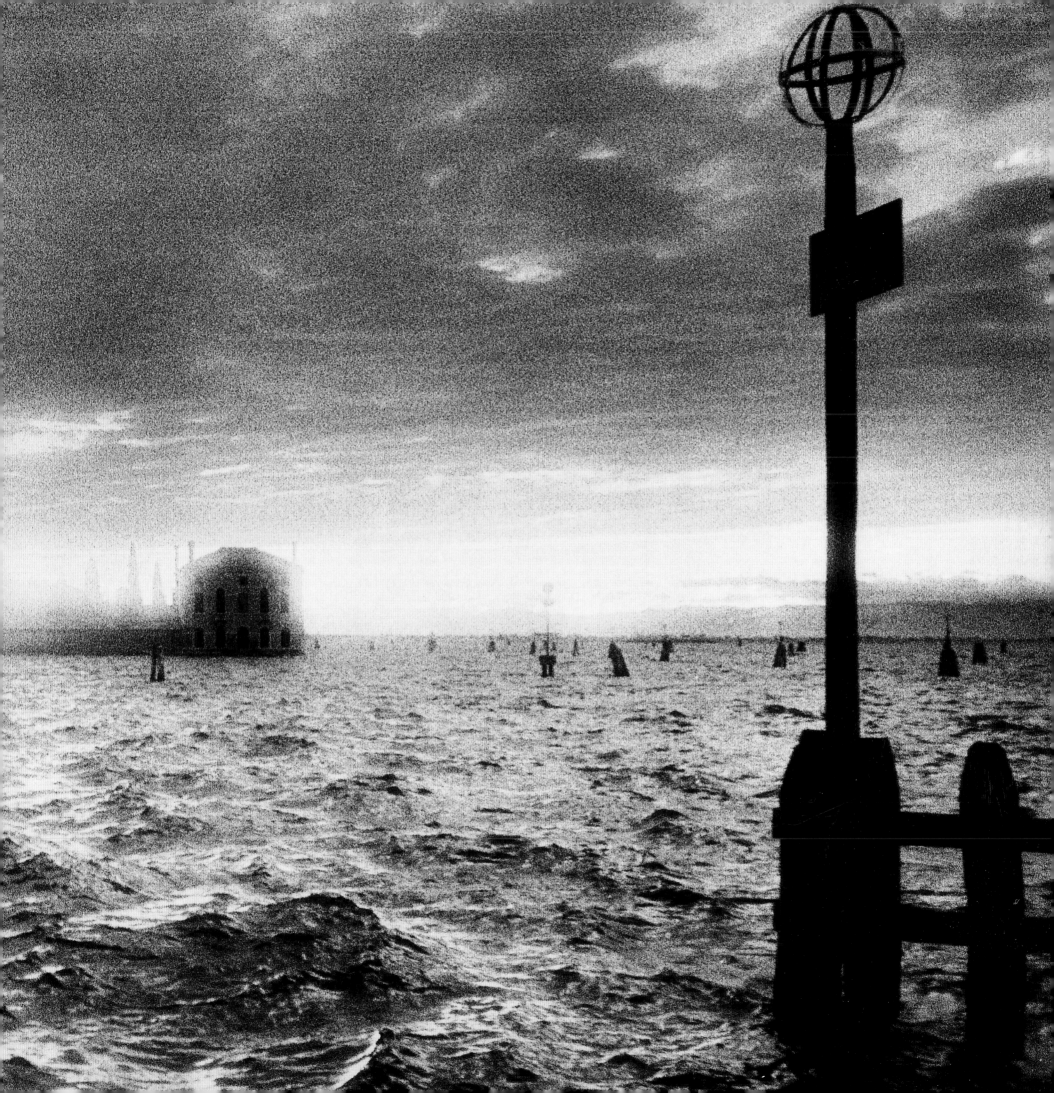

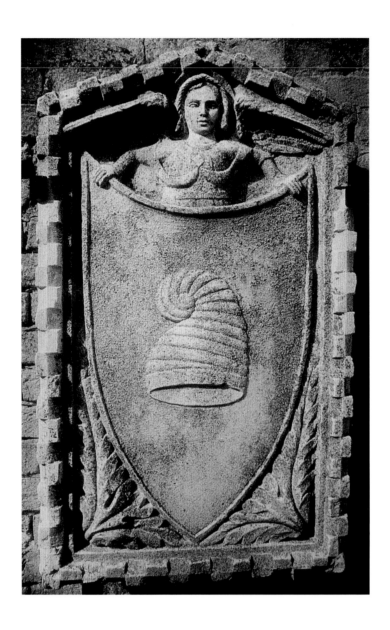

*I*f Enrico Dandolo or Francesco Foscari could be summoned from their tombs, and stood each on the deck of his galley at the entrance of the Grand Canal . . . the mighty Doges would not know in what part of the world they stood, would literally not recognize one stone of the great city, for whose sake, and by whose ingratitude, their grey hairs had been brought down with bitterness to the grave. The remains of *their* Venice – more gorgeous a thousandfold than that which now exists – lie hidden . . . in many a grass-grown court, and silent pathway, and lightless canal, where the slow waves have sapped their foundations . . . and must soon prevail over them for ever.

JOHN RUSKIN
The Stones of Venice, 1853

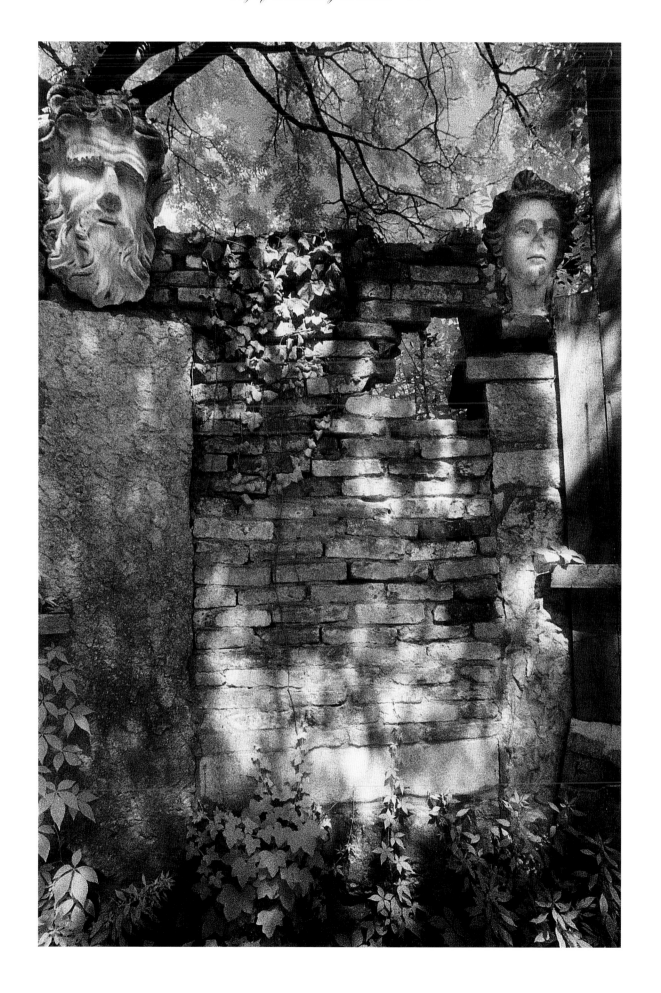

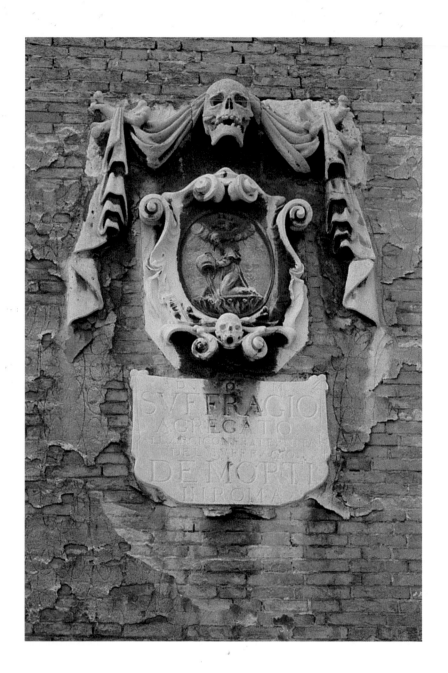

But close about the quays and churches, palaces and prisons: sucking at their walls, and welling up into the secret places of the town: crept the water always. Noiseless and watchful: coiled round and round it, in its many folds, like an old serpent: waiting for the time, I thought, when people should look down into its depths for any stone of the old city that had claimed to be its mistress.

Thus it floated me away, until I awoke in the old market-place at Verona. I have, many and many a time, thought since, of this strange Dream upon the water: half-wondering if it lie there yet, and if its name be VENICE.

CHARLES DICKENS
An Italian Dream, 1844

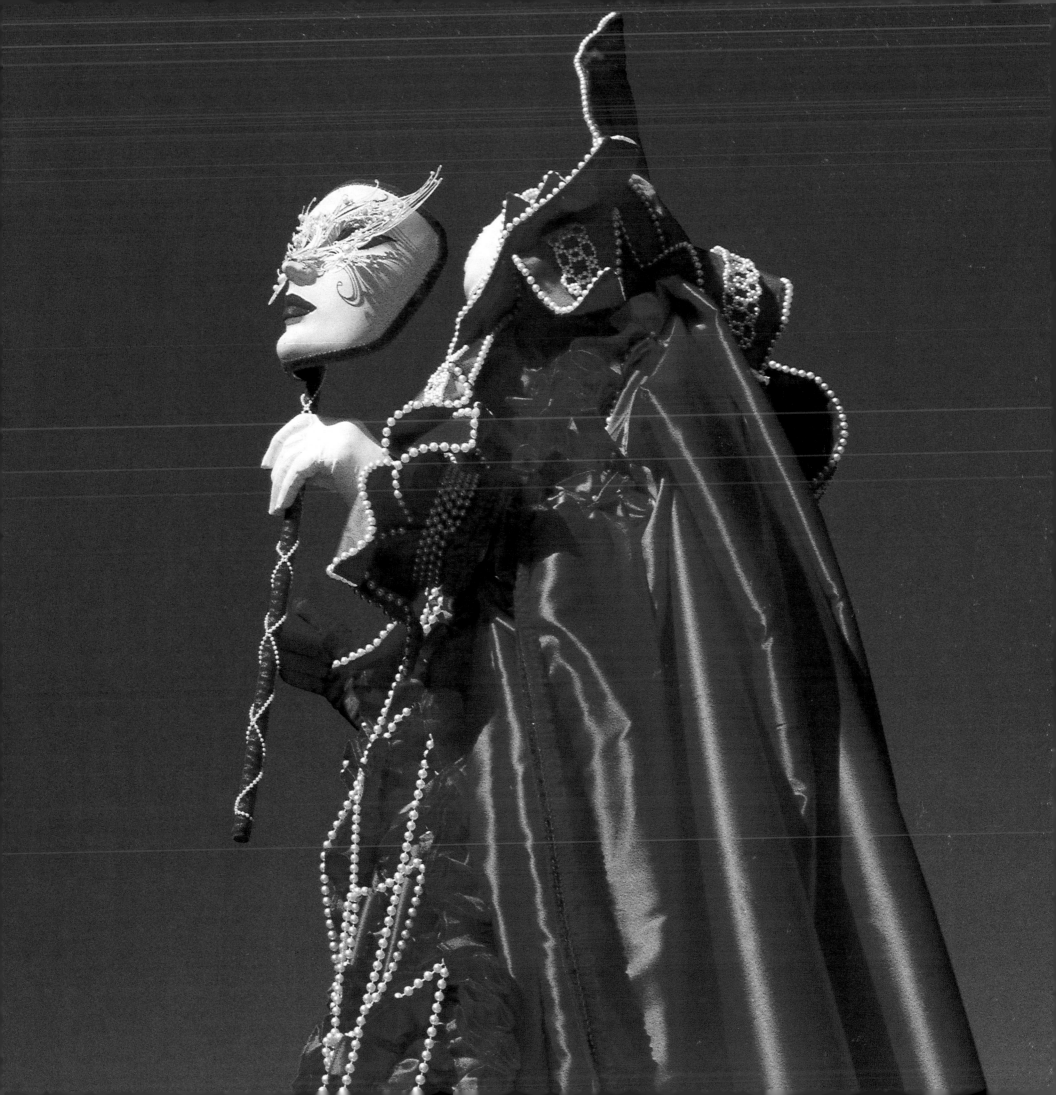

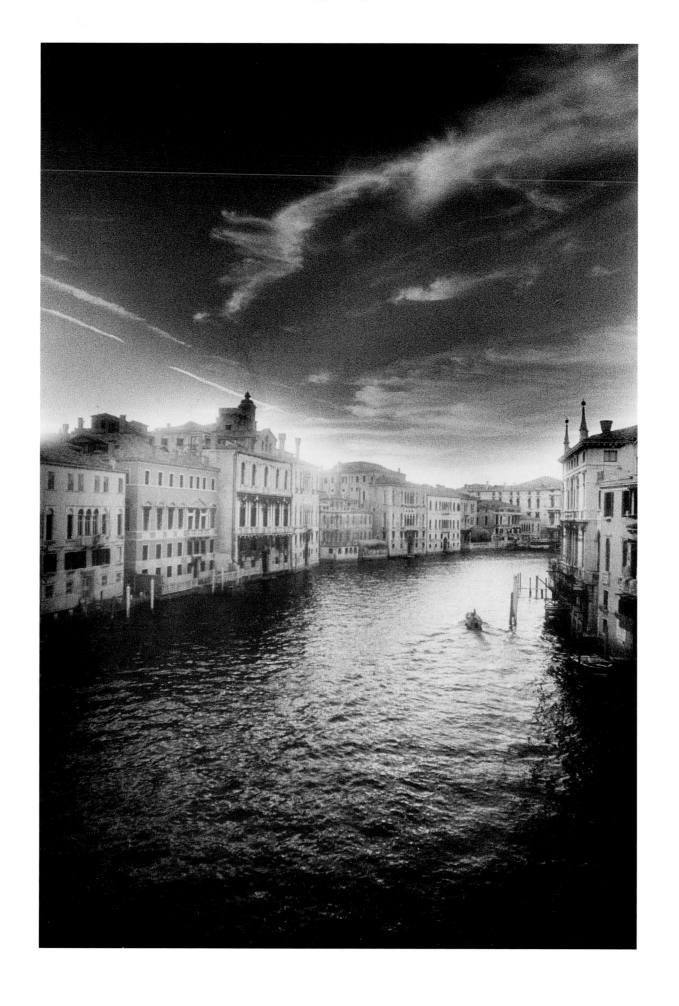

In Venice Tasso's echoes are no more,
 And silent rows the songless gondolier;
 Her palaces are crumbling to the shore,
And music meets not always now the ear:
Those days are gone – but Beauty still is here.
States fall, arts fade – but Nature doth not die,
Nor yet forget how Venice once was dear,
The pleasant place of all festivity,
The revel of the earth, the masque of Italy.

LORD BYRON
Childe Harold, 1817

THE LOCATIONS

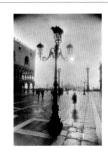

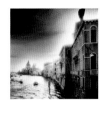

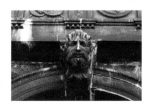

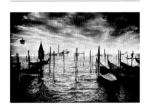

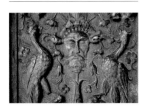

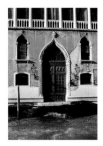

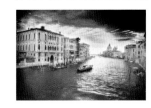

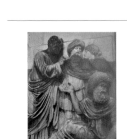

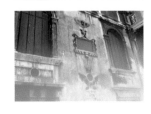

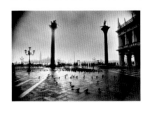

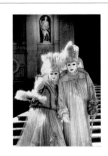

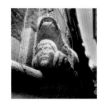

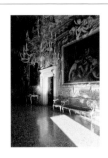

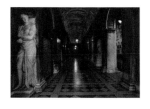

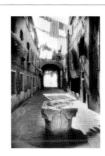

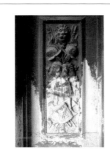

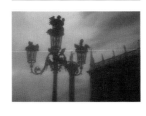

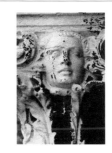

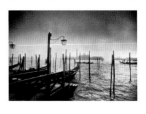

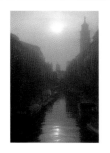

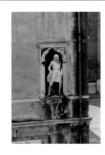

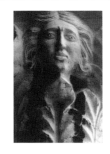

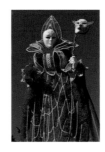

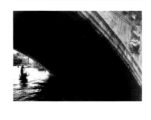

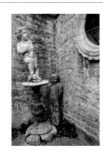

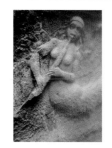

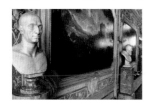

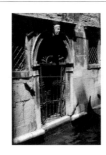

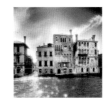

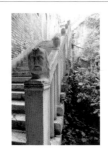

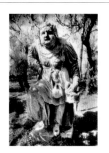

PAGE 46
Statue on the island of Torcello

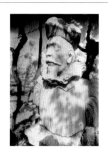

PAGE 46
Statue on the island of Torcello

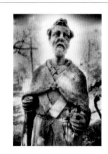

PAGE 47
Statue on the island of Torcello

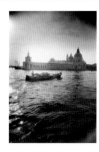

PAGE 48
Entrance to the Grand Canal,
close to the Basilica of Santa
Maria della Salute

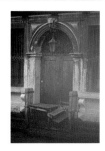

PAGE 49
Water entrance,
Rio della Toletta,
Dorsoduro

PAGE 50
Statue in the Giardini Pubblici,
Castello

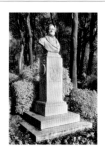

PAGE 51
Statue of Richard Wagner by
F. Schaper (1908),
the Giardini Pubblici, Castello

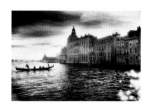

PAGE 52/53
The Grand Canal near the
Basilica of Santa
Maria della Salute

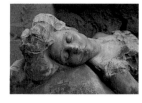

PAGE 54
The tomb of Sonia Kaliensky, the
island cemetery of San Michele

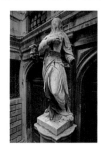

PAGE 55
Statue of a veiled woman in
the courtyard of Palazzo Pisani,
the Benedetto Marcello
Music Conservatory

PAGE 56
The tomb of the Doge Michelle
Steno, the church of S.S.
Giovanni e Paolo

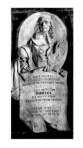

PAGE 57
Detail from the sepulchral
pyramid dedicated to the painter
Melchior Lanza, the church of
S.S. Giovanni e Paolo

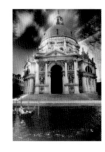

PAGE 58
The Basilica of
Santa Maria della Salute

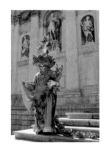

PAGE 59
Carnival figure on the steps of
Santa Maria della Salute

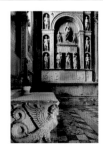

PAGE 60
Monument to the Doge
Giovanni Mocenigo, the church
of S.S. Giovanni e Paolo

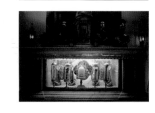

PAGE 61
Saints relics, Capella Molin, the
church of Santa Maria del Giglio

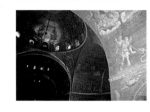

PAGE 62/63
Interior of St Mark's Basilica

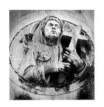

PAGE 64

Sculpture on the façade of the
Scuola Grande di San Marco

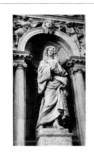

PAGE 65

Statue of a member of the
Barbaro family on the façade of the
church of Santa Maria del Giglio

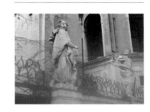

PAGE 66/67

Statues below the Basilica of
Santa Maria della Salute

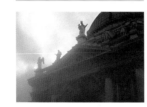

PAGE 68/69

Statues on the roof of the Basilica
of Santa Maria della Salute

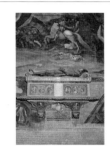

PAGE 70

The tomb of Jacopo Cavalli, the
church of S.S. Giovanni e Paolo

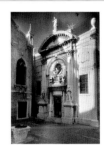

PAGE 71

The church of Santa Maria della
Misericordia, Cannaregio

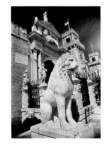

PAGE 72

Lions outside the gates
of the Arsenale

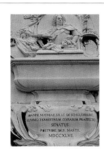

PAGE 73

Memorial plaque, the Arsenale

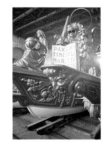

PAGE 74

Ceremonial barge in a boathouse
of the Arsenale Dockyards

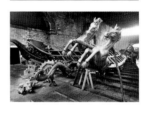

PAGE 74/75

Ceremonial barge in a boathouse
of the Arsenale Dockyards

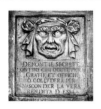

PAGE 76

Bocche di Leone (for the delivery
of anonymous accusations), the
Loggia of the Doge's Palace

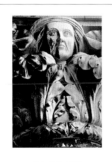

PAGE 77

Sculpture on a capital in the
Loggia of the Doge's Palace

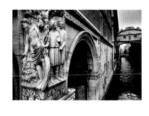

PAGE 78/79

'The Drunkenness of Noah' on
the corner of the Doge's Palace
leading to the 'Ponte dei Sospiri'
or the 'Bridge of Sighs'

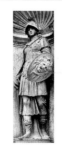

PAGE 80

Statue of Minerva by Jacopo
Sansovino, the Loggetta of the
Campanile, St Mark's Square

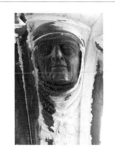

PAGE 81

Sculpture in the Gothic Arcade
of the Doge's Palace

PAGE 82

Detail on a capital in the Gothic
Arcade of the Doge's Palace

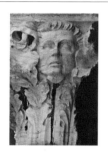

PAGE 83

Sculpture on a capital in the
Loggia of the Doge's Palace

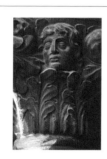

PAGE 84

Sculpture on a capital in the
Loggia of the Doge's Palace

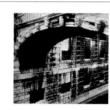

PAGE 85

The 'Bridge of Sighs' and the
prisons of the Doge's Palace

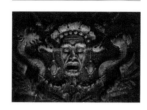

PAGE 86/87

Detail from a column on the
'Scala d'Oro' in the Doge's Palace

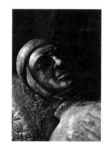

PAGE 88

Detail from the tomb of Doge
Michelle Steno in the church of
S.S. Giovanni e Paolo

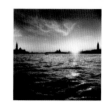

PAGE 89

The Bacino di San Marco

PAGE 90

Funerary sculpture, the island
cemetery of San Michele

PAGE 91

Bust of Carlo Padoan, the island
cemetery of San Michele

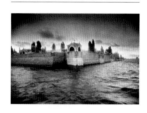

PAGE 92/93

San Michele Cemetery,
'The Island of the Dead'

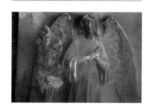

PAGE 94

Sculpture of an angel in the
cloisters of the church of
San Michele in Isola

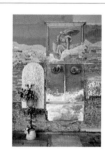

PAGE 95

Memorial in the cloisters of the
church of San Michele in Isola

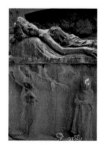

PAGE 96

The tomb of Sonia Kaliensky, the
island cemetery of San Michele

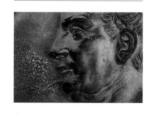

PAGE 98/99

Detail from a memorial plaque
in the cloisters of the church of
San Michele in Isola

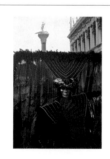

PAGE 99

Carnival figure

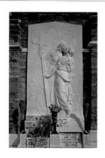

PAGE 100

Memorial, the island cemetery
of San Michele

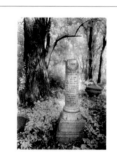

PAGE 101

Tombstones in the Jewish
Cemetery on the Lido di Venezia

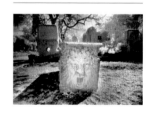

PAGE 102/103

Tomb in the Jewish Cemetery on
the Lido di Venezia

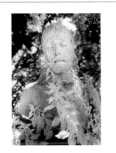

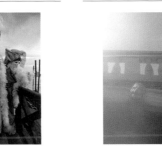

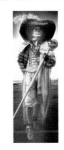

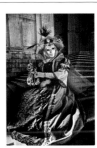

PAGE 107

Carnival figure

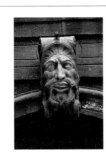

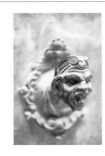

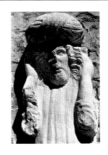

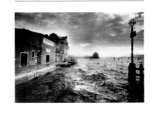

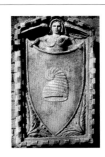

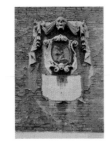

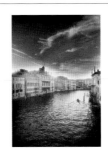

BIBLIOGRAPHY

Beckford, William, *Dreams, Waking Thoughts and Incidents*, 1783

Blessington, Marguerite, Countess of, *The Idler in Italy*, London, 1840

Byron, Lord, *Childe Harold's Pilgrimage*, 1817

Casanova de Seingalt, Jacques, *The Memoirs of Jacques Casanova de Seingalt*
(translated by Arthur Machen), London, 6 volumes, 1958-1960

Cole, Toby, *Venice, A Portable Reader*, New York: Frontier Press, 1979

De Sumichrost, F. C. (trans. & ed.), *Theophile Gautier, The Complete Works*, London:
Postlethwaite, Taylor & Knowles Ltd, 1901

Dickens, Charles, *Pictures From Italy*, London: Chapman & Hall Ltd, 1865

Facaros, Dana & Pauls, Michael, *Venice and the Veneto*, London: Cadogan Books Ltd, 1991

Hadfield, J. A., *Dreams and Nightmares*, London: Penguin Books Ltd, 1954

Honour, Hugh, *The Companion Guide to Venice*, Suffolk: Boydell & Brewer Ltd, 1965

James, Henry, *Italian Hours*, Boston: Houghton Mifflin, 1909

Keates, Jonathan, *Venice*, London: Sinclair-Stevenson, 1994

Lawrence, D. H., *Birds, Beasts and Flowers*, 1923

Mann, Thomas, *Death in Venice*, London: Secker & Warburg Ltd, 1928

Morris, James, *Venice*, London: Faber & Faber, 1960

Nietzsche, Friedrich, *Human, All Too Human*, 1878

Norwich, John Julius, *Venice, A Travellers' Companion*, London: Constable Ltd, 1990

Pemble, John, *Venice Rediscovered*, Oxford: Oxford University Press, 1995

Poe, Edgar Allan, *The Works of Edgar Allan Poe*, London, 6 volumes: George Routledge & Sons, 1896

Proust, Marcel, *Remembrance of Things Past*, New York, 4 volumes: Random House, 1934

Rolfe, Frederick, *The Desire and Pursuit of the Whole*, London: Quartet Books, 1993

Ruskin, John, *The Stones of Venice*, London: Smith & Elder, 1853

Shelley, P. B., *Posthumous Poems*, 1824

Symons, A. J. A., *The Quest for Corvo*, London, 1966

Tillotson, Kathleen (ed.), *The Letters of Charles Dickens*, Oxford: Clarendon, 1977

Twain, Mark, *The Innocents Abroad*, New York: The New American Publishing Company, 1901

Unsworth, Barry, *Stone Virgin*, London: Hamish Hamilton, 1985

Venice: Everyman Guide, London: David Campbell Publishers Ltd, 1993

Wagner, Richard, *My Life*, London: Constable Ltd, 1963

Wagner, Richard, *Venetian Diary*, 1858

ACKNOWLEDGEMENTS

My thanks to the following for their assistance in compiling this book:
Matteo Ballarin, Stephan Kechichian, Dr Gianni Pastro, Pietro Carretta, Lorenzo
and Justine Rubin de Cervin Albrizzi, Barone Ernesto Rubin de Cervin Albrizzi,
Salina Sella Marsoni, The Directors of the Conservatorio 'Benedetto Marcello',
Gigi Liani, Louise Berndt, The Curia Patriarcale di Venezia,
Susan Schiavon, Randy Michaelson, The Società Adriatica di Venezia,
Carlo Maria Rocca, Lt Santo Puntel, The Comando Marina Militare
di Venezia, The Cantiere Remiera Francescana, The Comune di Venezia,
Dr Adriana Cracun, David Young, Giles Gordon, Julia Charles, Rachel Connolly,
Clare Pemberton, Andrew Skirrow and Ronnie Adsetts of 'Amazing Internet'
and Matthew Ryder of 'A. Foster and Sons' Colour Laboratories.

A special thank you to the following for their inspiration, humour and invaluable
practical help: Andrew Barron, Patricia Liani, Rosie Mignaca and Denis MacEoin.

Finally to my wife Cassie for her never ending patience and understanding.

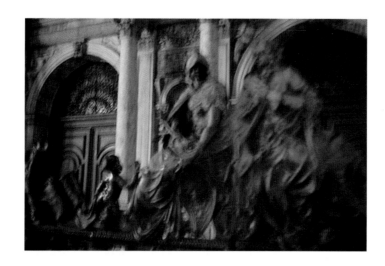

Out of the dark pure twilight, where the stream
Flows glimmering, streaked by many a birdlike bark
That skims the gloom whence towers and bridges gleam
Out of the dark,

Once more a face no glance might choose but mark
Shone pale and bright, with eyes whose deep slow beam
Made quick the twilight, lifeless else and stark.

The same it seemed, or mystery made it seem,
As those before beholden; but St Mark
Ruled here the ways that showed it like a dream
Out of the dark.

ALGERNON CHARLES SWINBURNE
'Venice' from *The Poems*, 1905